ABANDONED EASTERN PENNSYLVANIA

REMNANTS OF HISTORY

CINDY VASKO

AMERICA
THROUGH TIME®
ADDING COLOR TO AMERICAN HISTORY

I dedicate this book to my late husband, Stephen, an Eastern Pennsylvanian. The concept of closure is nonexistent when you lose someone you love. They are part of you forever. Our "lens" can impact what we discover in the world around us, and when we unearth a shattering secret, we become so focused on it that we often ignore all of the wonderful aspects of the person we lost. Forgiveness means it finally becomes insignificant that "you" established business operations in Russia almost thirty years ago, so I forgive. My book on Russia will never be closed, but it is time for me to let go of the story.

America Through Time is an imprint of Fonthill Media LLC
www.through-time.com
office@through-time.com

Published by Arcadia Publishing by arrangement with Fonthill Media LLC
For all general information, please contact Arcadia Publishing:
Telephone: 843-853-2070
Fax: 843-853-0044
E-mail: sales@arcadiapublishing.com
For customer service and orders:
Toll-Free 1-888-313-2665

www.arcadiapublishing.com

First published 2021

ISBN 978-1-63499-362-3

Typeset in Trade Gothic 10pt on 15pt
Printed and bound in England

CONTENTS

INTRODUCTION

I grew up in the Eastern Pennsylvania city of Allentown—population 121,000. I lived in the Allentown region until 1984 and then relocated to the Washington, D.C., metropolitan zone—population 3,100,000, and half of today's D.C. metro populace. While I lived longer in the dominion of our nation's capital than anywhere else, I still refer to Allentown as my home. I grew up in Eastern Pennsylvania's idyllic and prosperous era when jobs were plentiful and home life was stable. For the Eastern Pennsylvania generations before me, and those that escaped the dreadful conditions from two world wars, it was essential to look ahead—akin to a crude manifest destiny notion, not in the mid-nineteenth-century sense, but in an individualistic sense to maintain a dynamic, eyes-forward search for opportunities. Because looking back at tragedies and loss was often painful, my upbringing promoted onward-looking perspectives as one walked through life.

Additionally, good fortune, and not in the fiscal sense, attached to me at an early age. I had doting parents that believed in discipline, education, and independence, and I was fortunate to realize an excellent college and graduate school education. I also avoided becoming a victim of the heavy manufacturing collapse that invaded the Eastern Pennsylvania region in the latter part of the twentieth century.

I appreciate my providence with some correct life decisions, but like a draw of the cards, unfavorable luck enters the life equation at times. Nevertheless, I always thought it was advantageous to go through life, holding to a sense of attainable success at hand. Of course, one sets their life paths, but my parents instilled in me an expectation for a finer future, better opportunities, and not to look back if bumps arise along the journey. I am one of approximately 6 million baby boomers that fled the Rust Belt of the United States. I sought opportunity when I left Eastern Pennsylvania in 1984. Another 6 million boomers remained in the Rust Belt, with many suffering the consequences during America's heavy industry downturn.

My ancestors were coal miners, some were small businessmen, and some worked in textile factories. My favorite familial remembrance, though, is my great-grandmother evoking her tales of brewing, crating, and selling Prohibition-era whiskey, extracted from a liquor still hidden in the false floor of her dining room. My great-grandmother carried the centuries-old family whiskey recipe to the United States when she fled Stalinist Lithuania at sixteen years old. I inherited this wicked formula and, on occasion, proudly brew the Lithuanian concoction called Boilo, sans alcohol still.

Other family members emigrated from Sicily, Italy, and the United Kingdom, and almost all settled in Eastern Pennsylvania's anthracite coal region. The ravages of black lung disease, courtesy of coal mining, afflicted some of the family clan. Several relatives served our country during World War II and the Korean War. My father's wrenching stories and photographs of what he witnessed in Europe, Japan, and Korea, during his service in these wars, are forever seared in my memory, especially his accounts of his 45th Infantry Division's liberation of Dachau Concentration Camp, the German V-1 bombings of London, and his perspective of seeing Hiroshima, post-atomic detonation. Despite witnessing so much destruction and misery at a young age, my father always proclaimed, no matter what happens, to maintain focus on the future and depend on resourcefulness to wiggle through the kinks in life. Resourcefulness was in full throttle when I made the instantaneous decision to jump into the urban exploration fray, and I wish I could find the ingenuity key to unlock some of the personal jams that plague me today. Still, I am always hopeful (i.e. looking ahead) that I will find that magic key eventually. I like to believe I inherited some of my great-grandmother's whiskey-making *chutzpah* while I continue my strange journey into abandoned worlds. Damn the rules and keep to the advancing mission—do it or, in my case, go.

The past, and especially the many cultures one connects with, is vital for looking ahead to the future. The inherent truth of life, or even a culture, though, cannot be tricked together; it has to grow from deep cultivation in one's psyche and a weathering and honing of day-to-day life and experience. Many ethnic threads embed in my DNA, and I embrace this diversity because I openly assimilated the many histories and cultures of my family line. I like being a mutt.

Each family shares a history of many valuable lessons passed on to future generations. It is essential to continue the dialogue of the past, especially the life lessons. Seeing so many abandoned structures, with too many disappearing over the past eight years, has me contemplating that perhaps the only thing that ultimately survives are peoples' stories. Derelict frameworks, however, hold profound histories and anecdotes too. Just like familial tales passed through the ages, I want to preserve an abandonment's story with images of their perceived past grandeurs.

Eastern Pennsylvania holds many abandoned visions of former majesty and, unfortunately, anguish: the once-powerful Bethlehem Steel Company; the grand architecture of the Lansdowne Theater and Irem Shriners Temple; the historic J. W. Cooper High School; the lost love of a Pocono resort; the magnificence of a personal castle; the overgrown beauty of Mount Moriah Cemetery; the lost dreams of three textile factories; a Stonehenge-like canvas for rogue artists; the misery of rural communities; and the tragedies of Pennhurst State School and Hospital, Holmesburg Prison, and Eastern State Penitentiary. The abandoned stories I celebrate prompts a constant need to embark on more and more journeys for preservations of history—forward-thinking, headfirst movement, posterity.

1

THE VALUE OF A LIFE:
HOLMESBURG PRISON

People often ask if I witness ghostly sightings while photographing abandon-
ments. I can honestly say, never, but perhaps this is so because ghostly
encounters are not at the forefront of my endeavors—the composition of
my subject is my priority. During my shoots, I always try to avoid mental distractions
and kick my cold feet to the curb before entering an abandoned site. If ghosts exist,
however, they would surely make a permanent home within Holmesburg Prison.
Holmesburg's despondent and storied past flashes a bold vacancy sign for any
ethereal apparitions seeking lodging.

Alex M. Hornblums 1999 seminal book, *Acres of Skin: Human Experiments
at Holmesburg Prison*, reveals shocking accounts of abuse and exploitation on
Holmesburg inmates in the name of science and commerce. Inmate skin served as
the science lab for Dr. Albert Kiligman's dermatological trials. With experimentation
occurring in the early 1950s to the early 1970s, hundreds of prisoners, if not
thousands, were akin to laboratory animals as the subjects for the testing of products
from facial balms to harmful substances such as chemical and radiological agents.
Hornblum's manuscript paints an alarming landscape of maltreatment, moral
indifference, and greed in the service of the pharmaceutical sector. Furthermore,
in return for small fees, prisoners were infected with ringworm, warts, herpes,
and other bacteria, while other inmates incurred exposure to highly toxic drugs,
ultraviolet rays, radioactive isotopes, and dangerous chemicals such as dioxin.
The side effects to the prison populace emanating from these experiments were
endless and included hallucinations, delirium, memory loss, burns, and cognitive
performance impairment, along with many more maladies. Yes, if ghosts exist, one
would surely find them within the stone fortress named Holmesburg.

The City of Philadelphia and Pennsylvania Department of Prisons operated
Holmesburg Prison from 1896 to 1995. The facility closed and decommissioned
in 1995. In addition to scientific experiments conducted on Holmesburg inmates,
the site is famous for several significant riots in the early 1970s. Additionally, an

alarming two-year investigative account by the Offices of the Philadelphia Police Commissioner and the District Attorney of Philadelphia documented hundreds of cases of inmate rape. Despite its dreadful history, Holmesburg's latter operational years yielded to a model of excellence concerning the actions of its correctional staff. At this time, the prison was proactive with modern correctional procedures featuring a focus dedicated to inmate reentry to society, and positive development and educational programs. The reform of Holmesburg practices, though, did not save it from closure in 1995.

The Hippocratic Oath, the Nuremberg Code, and later, the Declaration of Helsinki serve as important ethics markers for all societies. These codifications open one's eyes to the universe of inconceivable and inhumane experiments carried out in the name of science. *Acres of Skin* underlines the twentieth century's absence of moral principles within a prison where business objectives usurped the welfare of human beings, despite the declarations of Nuremberg or Helsinki mere years and decades earlier. Holmesburg served as a callous and cavalier laboratory on too many occasions for too many years and represented a dark chapter in American history.

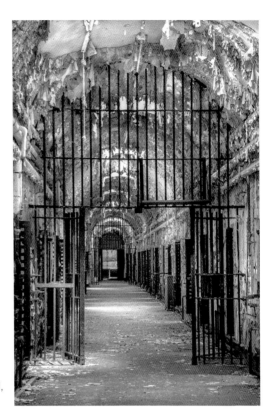

CELLBLOCK: For decades, Holmesburg Prison incurred notorious dermatological, pharmaceutical, and biochemical testing on inmates.

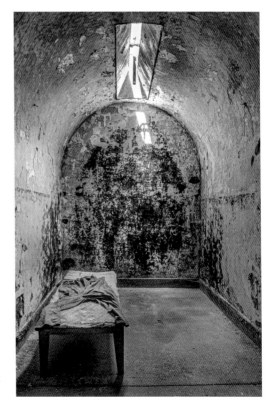

CELL AND PRISON JUMPSUIT: Until 2017, tactical police training exercises were practiced at the closed Holmesburg prison site.

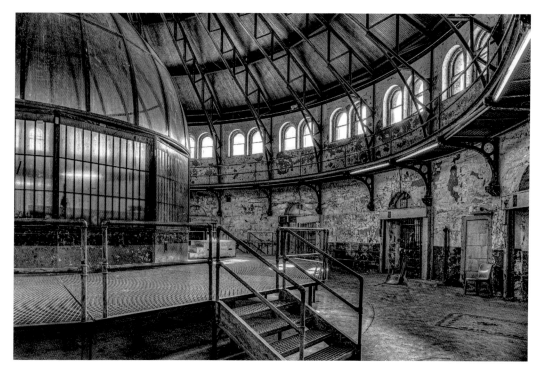

CELLBLOCK ENTRY CORE AND MOVIE PROP: The dome in the center of Holmesburg's cellblock floor plan is a movie prop from the 1996 movie *Up Close and Personal.*

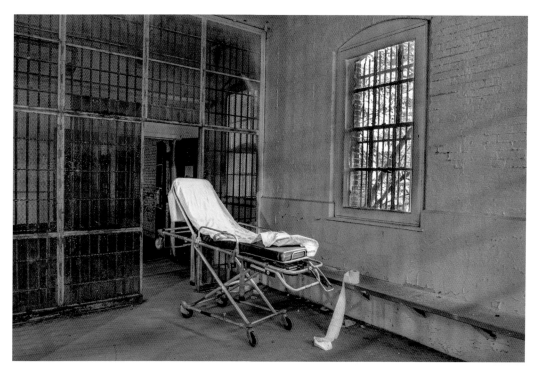

PRISON GURNEY: Upon his initial entry into Holmesburg Prison, Dr. Albert Kligman saw the inmates as acres of skin for his medical experiments.

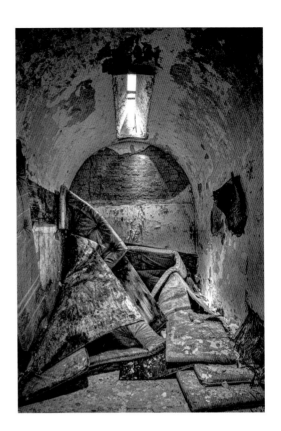

PADDED CELL: In many instances, Holmesburg prisoners agreed to brutal medical tests in exchange for small monetary rewards.

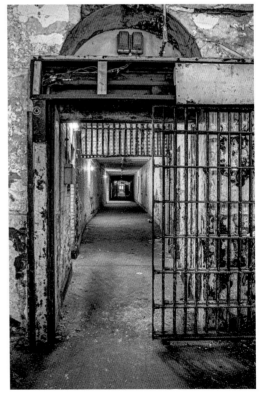

CELLBLOCK: Abandoned Holmesburg was the movie set for the production of several films including *Law Abiding Citizen*, *Fallen*, and *Up Close and Personal*.

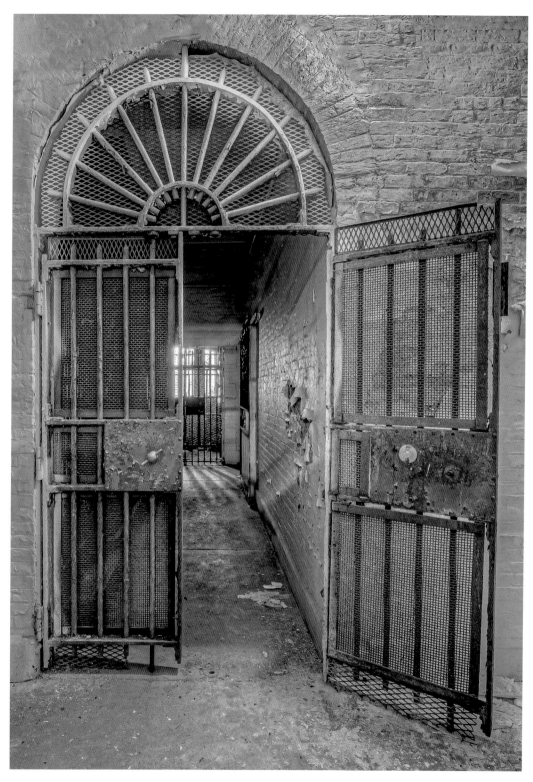

CELLBLOCK TO HALLWAY: In 1973, Holmesburg inmates killed Warden Patrick Curran and Deputy Warden Major Robert Fromhold.

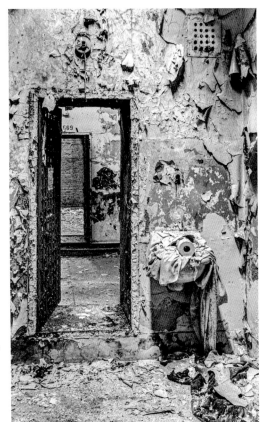

▲ **CELL:** In the 1980s, former prisoners who participated in Holmesburg dioxin experiments filed lawsuits against Dow Chemical. In 2000, other parties, such as Dr. Kligman, Johnson & Johnson, and the University of Pennsylvania faced class-action lawsuits filed by 298 former prisoners.

▼ **REINFORCED METAL DOOR AT END OF CELLBLOCK CORRIDOR:** On July 4, 1970, a riot occurred at Holmesburg, and over 100 people were injured.

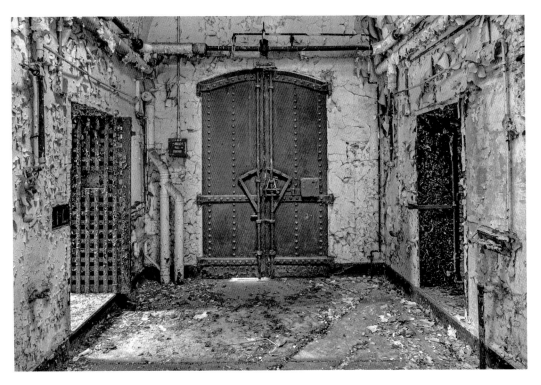

2

SCHOOL DAZE:
J. W. COOPER HIGH SCHOOL

I recall lengthy discussions with my father about his high school, J. W. Cooper ("Cooper"), in Shenandoah. I also remember my great-grandmother and grand-mother speaking of the devastating Spanish flu at the beginning of the twentieth century. Absent a vaccine to combat the Spanish flu, this epidemic of 1918–1920 infected 350,000 Pennsylvanians. Curiously, the Spanish flu has a connection with Cooper. As I walked through Cooper with my camera in hand, I relived my father's fondness and stories about Cooper, especially with regard to the impressive auditorium, the indoor swimming pool, and the large gym. My father's last footsteps in Cooper were on graduation day, 1943, and immediately after that, he departed on a conscripted journey to the World War II European theater.

In the 1920s and 1930s, Shenandoah was the most densely populated area in the United States and held 30,000 residents within its one-square-mile footprint. The increasing population demanded the construction of more schools. The Shenandoah High School, later named Cooper, was scheduled to open in 1918. Because Pennsylvania, and especially Shenandoah's Schuylkill County, was overwhelmed by the ravages of the Spanish flu at this time, the local hospitals were at capacity and overburdened. Instead of an inaugural Cooper opening in 1918, the school served as a temporary hospital and morgue. In 1919, Cooper finally met its original purpose and became a school.

Cooper's indoor swimming pool, although not as grand as I envisioned it based on my father's tales, is the oldest indoor swimming pool for a United States school and Pennsylvania's second oldest pool. The jewel of the school, however, is the beautiful and ornate 800-seat auditorium. This stunning auditorium includes a circle level of seating, a large stage, and decorative moldings and carvings at the crown and along the circle level face.

Cooper closed as a high school in 1981 and reopened as an elementary school until its closure in 1994. The decline in coal mining after World War II and deterio-rating tax base contributed to the school's lower enrollments and eventual closure.

In post-war Shenandoah, many left the town for larger towns or cities, and my father joined this exodus.

Shenandoah's population, once at 30,000, is now 4,800. Not only is Cooper school silent, but so many homes and businesses are shuttered or burned—a common site throughout the coal towns of Schuylkill County. Cooper school, however, is fortunate to have a caretaker and one that is assuming the restoration of the school. The roof was replaced, along with many broken windows. Electricity and plumbing returned to this school. The removal of debris, unfortunately, seems to be an ongoing and seemingly endless project. The new owner wants to convert Cooper into a community center with a mixed-use of tenants and services—stores, offices, and use of the gymnasium. Cooper is still closed to the public because it is still not ADA compliant. Nevertheless, tax deduction contributions are always welcomed to further Cooper's rehabilitation and progress toward ADA compliance.

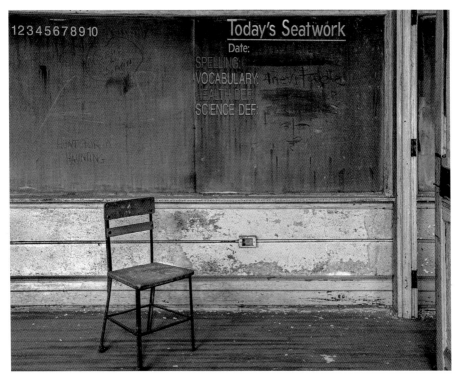

CLASSROOM: Originally known as Shenandoah High School, the school was later named J. W. Cooper School to honor a Shenandoah community school supervisor.

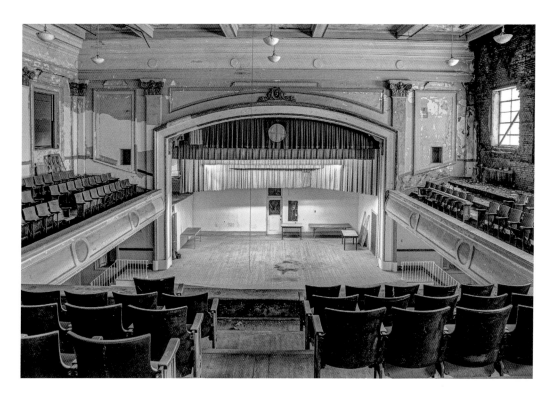

▲ **AUDITORIUM:** In addition to holding a large stage, the auditorium seated 800 with two levels of seating.

▼ **CLASSROOM:** When the Spanish flu devastated Schuylkill County in 1918–1920, Cooper was used as a hospital and morgue before it opened as its designated purpose, a school. 350,000 Pennsylvanians were infected with the Spanish flu, and Schuylkill County was especially hard hit.

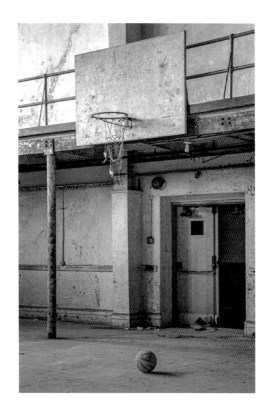

▲ **GYMNASIUM:** In the late 2000s, a local jewelry store owner took control of Cooper and began restoration of the school.

▼ **ABANDONED REPORT CARDS:** Jerry Wolman, once part owner of the Philadelphia Eagles and the Philadelphia Flyers, attended Cooper school.

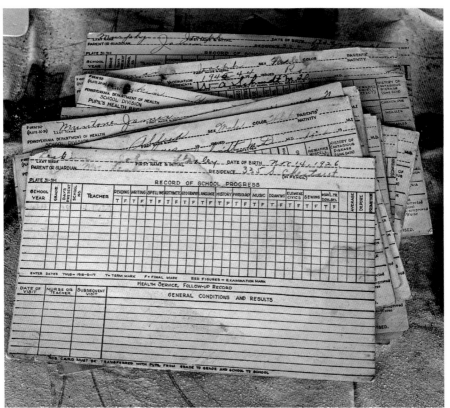

3

A PORTRAIT OF SUFFERING:
PENNHURST STATE SCHOOL AND HOSPITAL

My father was a news devotee, and I absorbed his passion with enthusiasm and at an early age. Even at five years old, I remember the influence of certain major news events, such as the Kennedy–Nixon presidential election, and a short time later, the Cuban Missile Crisis. Another major news happening that burned in my memory concerns a 1968 five-episode NBC Philadelphia newscast feature, by journalist Bill Baldini. The series, an exposé of Pennhurst State School and Hospital ("Pennhurst") conditions, unfolded over five evenings with each episode at five minutes. "Suffer the Little Children" was a raw documentary about neglect and abuse housed at Pennhurst. I remember viewing my parents' moist eyes as images of severely disabled adults chained to adult-sized cribs, and children in cages with little attention to their mental or physical needs flashed across the television screen. These appalling images will never leave me. This series had an impact, and the short, sense-jolting episodes were instrumental to the closing of this institution and provided a framework for the human rights movement that revolutionized America's approach to healthcare for mentally and physically disabled citizens.

Pennhurst commenced operations in 1908 and was initially called the Eastern Pennsylvania Institution for the Feeble-Minded and Epileptic, due to rising demands for the housing of mentally and physically disabled citizens, as well as immigrants, criminals, and orphans. Within a few years of Pennhurst's opening, patient overcrowding was the norm. In 1913, the Commission for the Care of the Feeble-Minded declared that it did not recognize individuals with disabilities as citizens and declared them as dangers to society. Patients holding mental disabilities at Pennhurst were grouped into several categories, such as imbecile or insane, and those with physical impairments were either epileptic or healthy.

By the mid-1960s, Pennhurst boarded nearly 3,000 patients, mostly children, and about 900 more than it could quarter comfortably. Almost everyone viewing "Suffer the Little Children" knew Pennhurst's future was in peril. The long and complex legal processes, however, protracted Pennhurst's lifecycle for two more

decades. By the 1980s, overcrowding, funding shortages, insufficient staffing, decades of ill-treatment, and complaints of neglect forced the facility's closure in 1987. Pennhurst's death was not in vain, though, as the practices of this hospital and school set in motion the necessary nationwide changes to medical practices in similar medical and mental health institutions.

I visited Pennhurst on two occasions. Pennhurst is a vast campus holding many buildings with imposing architecture. The overgrowth of grasses and trees, along with the wind blowing across the campus and between the many buildings, presents otherworldly scenes and sounds. I am not the type of person that is easily shocked because of my penchant for urban exploration, but with every turn on a campus trail, every stroll down an abandoned Pennhurst hallway, every sight of toys strewn about the floors in several hospital rooms, I recalled the 1968 Pennhurst documentary, and sadly, easily imagined the torment of the poor souls sequestered in this institution. The children and adults that suffered at Pennhurst were removed from society to safeguard humanity, but who at Pennhurst was present to shield these adults and children from the cruelty of society? Decades were required to correct Pennhurst's brutal path of inhumanity, and the patients of Pennhurst were the martyrs in service to the needed and overdue reformed practices of large health institutions.

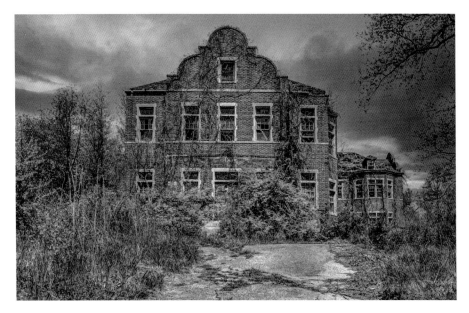

WARD: Many of the Pennhurst buildings, including this one, were two-storied and featured red brick, terracotta and granite trim. Architect Phillip H. Johnson designed many of the buildings.

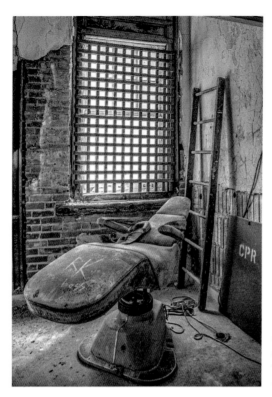

MEDICAL EXAM RECLINER: On November 23, 1909, Patient Number One was admitted to Pennhurst. Within four years of Pennhurst's opening, the facility experienced overcrowding and encountered societal pressure to accept further groups of orphans, criminals, and immigrants.

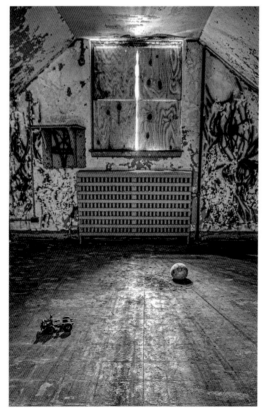

PATIENT ROOM WITH TOYS ON FLOOR: Pennhurst's wards held a large number of small rooms with two or three beds, as well as a few small dormitories of eight to ten beds.

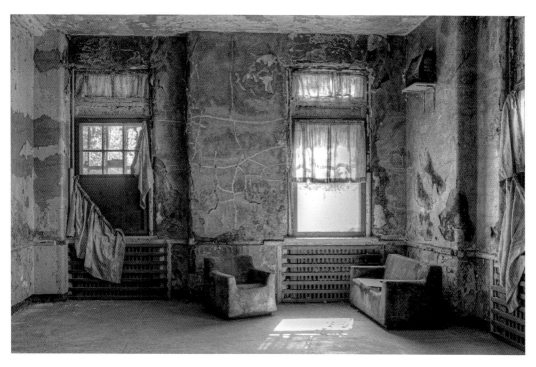

COMMUNITY ROOM IN WARD: The Pennsylvania Railroad built Pennhurst Station to accommodate Pennhurst's powerhouse as well as the delivery of supplies to Pennhurst. Boxcars moved directly onto the main campus.

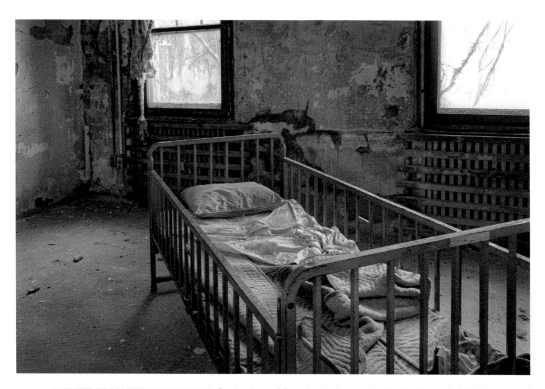

PATIENT ROOM WITH ADULT CRIB: Contentions of Pennhurst abuse led to the first lawsuit of its kind, as well as a federal class action in Halderman *v.* Pennhurst State School & Hospital.

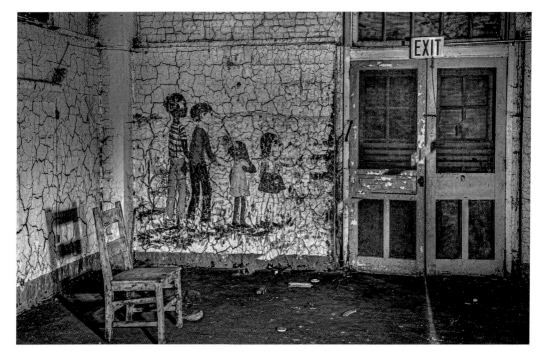

LIGHT PAINTED PLAYROOM IN BASEMENT OF WARD: Halderman *v.* Pennhurst State School & Hospital ruled that developmentally disabled citizens in the hands of the state have a constitutional right to suitable care and education.

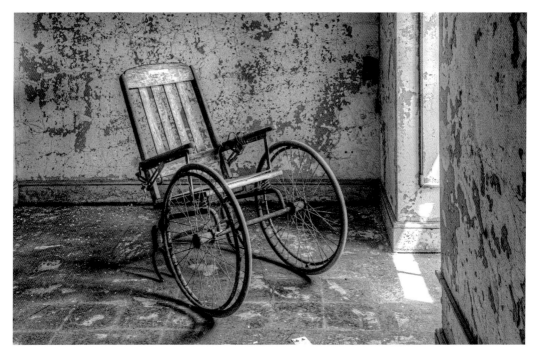

ANTIQUE WHEELCHAIR: Due to Pennhurst's cruel and harsh conditions, courts found Pennhurst in violation of the Fourteenth and Eighth Amendments, and the Pennsylvania Mental Health and Retardation Act of 1966. The Supreme Court, however, vacated the judgment; based on the Eleventh Amendment in that federal courts must not direct state authorities to comply with state laws.

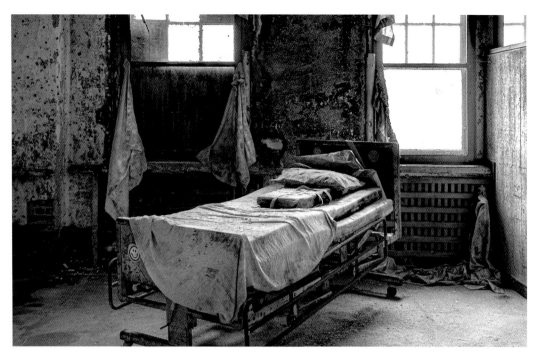

PATIENT ROOM: The Supreme Court case, Pennhurst State School and Hospital *v.* Halderman, bore the Pennhurst Doctrine, which mandated community-based services available to all citizens.

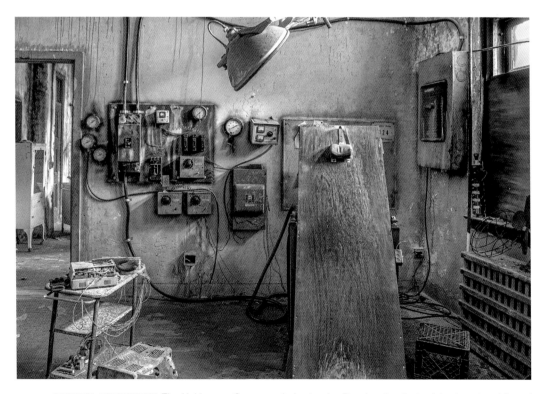

MEDICAL EQUIPMENT: The Halderman Case revealed extensive Pennhurst patient mistreatment and forced the closing of Pennhurst.

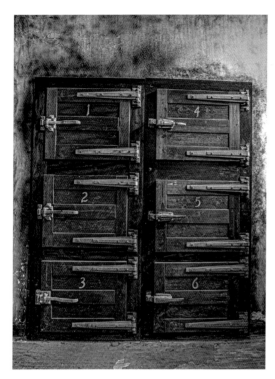

MORGUE: In 1983, nine Pennhurst personnel were indicted on a range of charges from beating patients, including some in wheelchairs, to the coordination of patients' assault of each other.

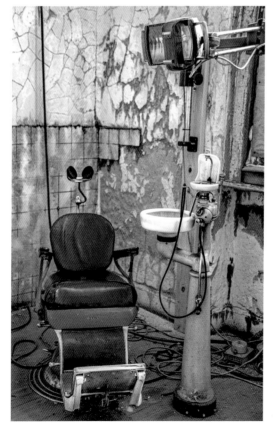

DENTAL FACILITY: Upon admission to Pennhurst, patients were categorized into mental classifications of imbecile or insane, physical classifications of epileptic or healthy, and dental classifications of good, poor, or treated teeth.

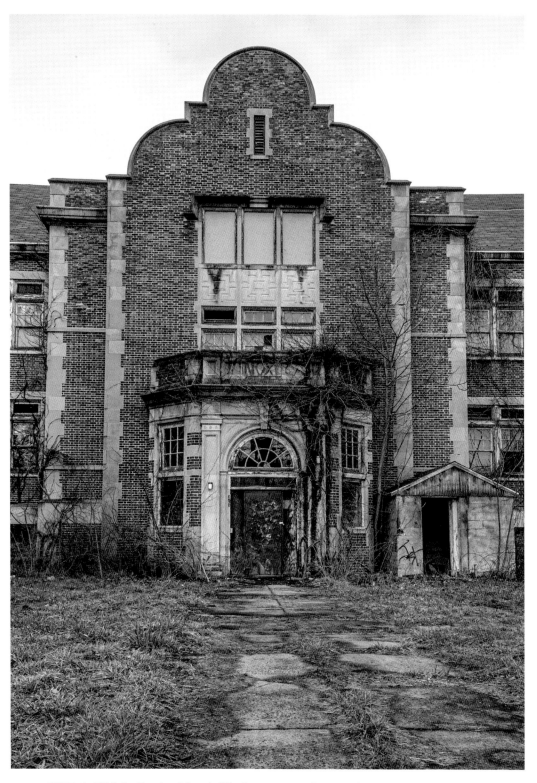

WARD: In 1916, the Pennhurst Board of Trustees constructed cottages for women to segregate them from men and the prevention of pregnancies.

4

A MAN'S HOME IS HIS CASTLE:
FONTHILL ESTATE

Driving down a long driveway framed by graceful mature Sycamore trees, one reaches a magnificent piece of fairytale architecture that looks like it would be more at home on the rolling greens of Scotland, instead of Pennsylvania. The beautiful castle-like home of American archeologist, anthropologist, ceramist, scholar, antiquarian, and tile maker, Henry Chapman Mercer, stands tall and proud on its manicured lawn of 80 acres. Mercer's home, known as Fonthill Castle, built between 1908 and 1912, holds a diverse architectural mix of medieval, Gothic, and Byzantine styles and is an early example of poured reinforced concrete construction. On the one side of the castle is a spring from which the palace derives its name: Fonthill.

The interior of the house is just as eclectic, if not more so than the exterior, as it is resplendent with American arts and crafts designs. Stunning colors, tiling, and ceramics adorn the ceilings, walls, and floors of the home and its forty rooms. Mercer designed many of the interior tiles, and some designs convey historical accounts such as the voyages of Christopher Columbus or Cortez, while others reveal biblical stories or tales of the New World. Some of Mercer's tiles in Fonthill date to 2300 B.C. The home also possesses an extraordinary collection of books—thousands of them. Further, countless artifacts from Mercer's international travels are present and include ancient Babylonian clay tablets as some of Mercer's more curious objects.

Mercer loved tiles so much he also built a Spanish-mission architectural style shop on the Fonthill property, to serve as the Moravian Pottery and Tile Works. Mercer's pottery and tile business flourished during the height of the arts and crafts movement, with many of Mercer's tiles installed in several prominent buildings.

Mercer lived in his castle from 1910 until his death in 1930 and passed away without heirs. Mercer, however, placed Fonthill in trust to be a museum, but with the condition that his housekeeper and assistant, Laura and Frank Swain, continue to live at Fonthill until their deaths. Laura Swain's husband preceded her in death, and Laura Swain's passing occurred in 1975, at which time Mercer's castle became a museum and opened as such in 1976.

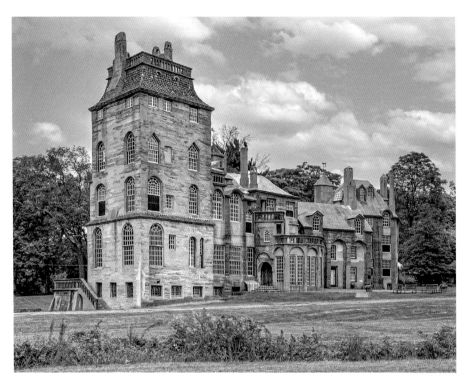

FONTHILL CASTLE: Using hand-mixed concrete and the trial and error technique, ten unskilled craftsmen and one horse constructed Henry Chapman Mercer's home. Lucy, the horse, carried the concrete during the construction process.

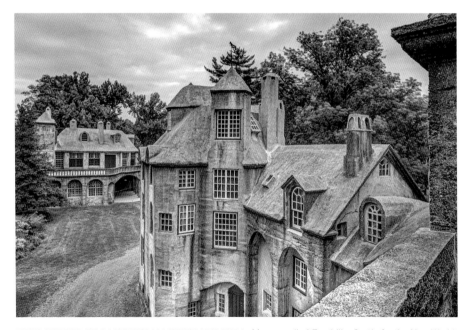

VIEW OF REAR OF CASTLE FROM UPPER VERANDA: Mercer called Fonthill a Castle for the New World.

ENTRANCE TO CASTLE FROM UPPER VERANDA: Fonthill departs from architectural and design guidelines and holds a massive display of tiles of various kinds.

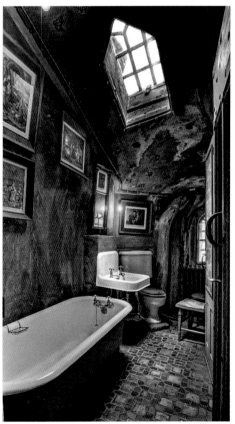

BATHROOM: During Mercer's 1984 visit to the countryside in Derbyshire, England, Mercer visited Haddon Hall—a fortified twelfth-century medieval manor house, and incorporated some of Haddon Hall's design elements into Fonthill.

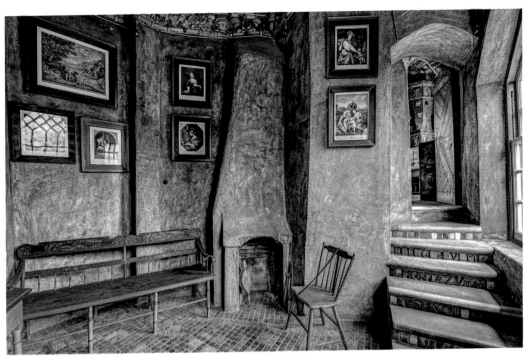

SITTING AREA NEXT TO OFFICE AND READING ROOM: The Fonthill Castle construction workers received $1.75 in wages per day. Mercer commemorated the ten workers and Lucy the horse with an inscription on a tile affixed on the ceiling of Fonthill's servant wing.

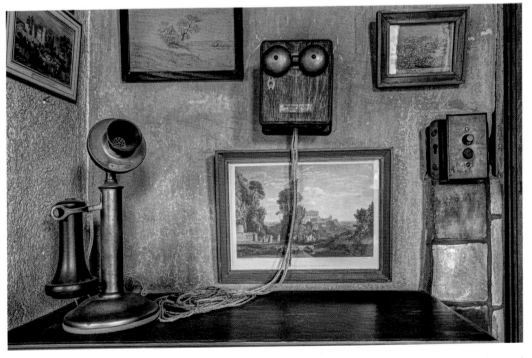

OLD TELEPHONE: Mercer traveled extensively through Europe in the last half of the nineteenth century and assumed inspiration for Fonthill from his European travels.

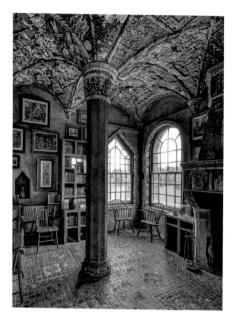
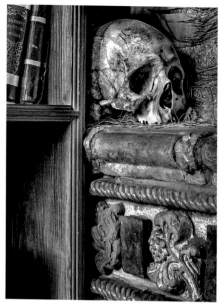

◄ **OFFICE AND READING ROOM:** Mercer was fifty-one years old when he began construction on Fonthill in 1908. Fonthill is one of three concrete buildings Mercer constructed in Doylestown. The other two buildings are the Moravian Pottery and Tile Works and the Mercer Museum.

► **HUMAN SKULL IN OFFICE AND READING ROOM:** Fonthill holds forty-four rooms, including ten bathrooms and five bedrooms. There are more than thirty-two stairwells, more than 200 windows, and eighteen fireplaces in Fonthill.

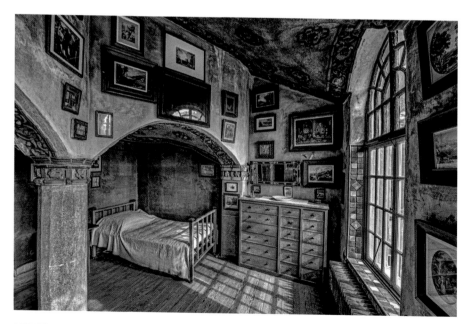

MERCER'S BEDROOM: Upon his death in 1930, Mercer left his home in trust as a museum, but not before the expiration of life rights granted to his housekeeper and her husband, Laura, and Frank Swain. Mrs. Swain passed away in 1975 upon which the Trustees of the Mercer Fonthill Museum assumed operation of Fonthill as a museum.

5

WHEN DEATH WAS BEAUTIFUL:
MOUNT MORIAH CEMETERY

Some studies surmise that before the end of the twenty-first century, the deceased memorials on Facebook will outnumber those of the living Facebook participants. Of course, all of this is contingent on Facebook being an actual entity eighty years from now. Still, this scenario begs the question: will virtual cemeteries soon replace traditional burial sites?

Visiting cemeteries to honor departed loved ones was an annual tradition in my family. Each Memorial Day, I would accompany my parents to the family gravesites, and participate in the careful placement of flowers and American flags in spots of honor. During my childhood, I remember cemeteries holding enormous sprays of complex flower arrangements, some life-size, along with endless landscapes of color, as tributes to loved ones. As years progress, I see less and less color in cemeteries on Memorial Day. Does our obsession with everything virtual, as well as the generic nature of modern cemeteries, lend to this waning of tributes? In contemporary cemeteries, granite tombstones and especially monuments and family crypts are absent with flat bronze grave markers as substitutes for the grandeur of the past. Acres and acres of flat green manicured lawns now assume the place of the granite memorial topiary landscape of the old, particularly nineteenth-century cemeteries.

There was nothing trite or generic, however, about the abandoned Mount Moriah Cemetery in Philadelphia and Yeadon, Pennsylvania. Mount Moriah is glorious and commanding even in its abandoned state. A Norman Castle-style brownstone gatehouse, formerly the entrance to the cemetery, is the initial dominant sight as one enters the burial site at the Philadelphia entrance. The gatehouse's single-gated arch, once topped with the striking statue of Father Time, now has Father Time shadowing the gravesite of the former president of the Mount Moriah Cemetery Company.

Mount Moriah is historic. Veterans' gravesites from those that served the Revolutionary War through the Vietnam War, including twenty Medal of Honor recipients, claim turf in Mount Moriah. Betsy Ross's remains, once interred at Mount

Moriah, now rest at the Betsy Ross house, but an American flag still honors Ross's former Mount Moriah resting place.

It is not difficult to imagine the former beauty of this place. Monuments reach to the sky and peek from the tall brush and trees growing unencumbered around each of the stone markers. Extravagant mausoleums occupy a sizeable footprint of the cemetery. These beautiful stone family crypts shout culture and taste about an antecedent aristocratic class. I am sure in Mount Moriah's prime, the landscaping around these crypts, as well as the cemetery's other grand monuments, once featured lush trees, flowers, and elaborate gardens with living walls and hedges.

The Pennsylvania Legislature established and incorporated Mount Moriah in 1855. The cemetery is 200 acres and spans part of Philadelphia, as well as a portion of Yeadon, Pennsylvania. In its early days, the cemetery was accessible by streetcar and allowed burials of Jews, African Americans, and Muslims.

In 2011, Mount Moriah closed its gates along with the unsettled question of its ownership. Mount Moriah soon yielded to nature's enthusiastic hand and became an unfortunate depository for illegal dumping. In short order, the structures, mausoleums, graves, and monuments of Mount Moriah decayed from neglect. A non-profit organization, the Friends of Mount Moriah Cemetery, formed and commenced an intense effort to clear the wild foliage and trash on the cemetery grounds, and took steps to preserve the gravesites and steady the decomposing, unstable gatehouse.

Contemporary society experienced a cultural shift in burial practices within the last several decades, and especially with cremation becoming more socially acceptable. Families, not centrally located as they once were, do not feel the need for permanent granite markers for their beloved deceased. Often, the only burial option is interment in a modern cemetery and one that frequently looks like a lumpy generic plane of green grass. In addition to Facebook's Memorial State pages, virtual cemeteries and online memorials make global appearances with increasing frequency. As technology advances toward a life in which both the home and the office become temporary, tributes to the deceased mutate into memory links where one can view slide shows or hear podcasts about their lost ones. Will digital interfaces replace tactile memorials?

We mourn the loved ones that left us. The cemetery is a natural setting where people can lament their loss, and symbolize that loss through tangible memorials. Memorials are physical expressions of the memory and loss that connect one to another and past families to future generations. Mount Moriah, with its history, grandeur, and elegance, is a long lost societal standard, but one that needs preservation. All of us want to be remembered, and those interred in Mount Moriah should be held in a state of respect, not neglect. Fortunately, the good volunteers of the Friends of Mount Moriah Cemetery are assuring this standard of reverence be set in stone.

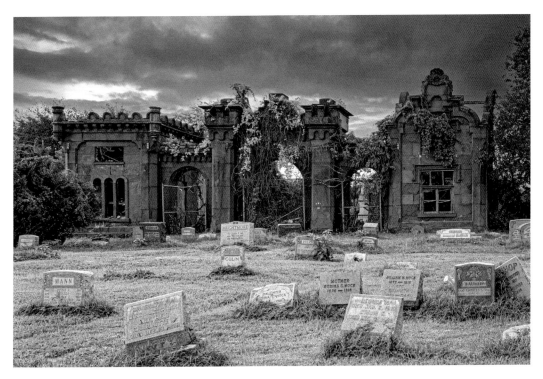

GATEHOUSE: A Norman castellated brownstone gatehouse graces Mount Moriah Cemetery. Stephen Decatur Button designed the gatehouse.

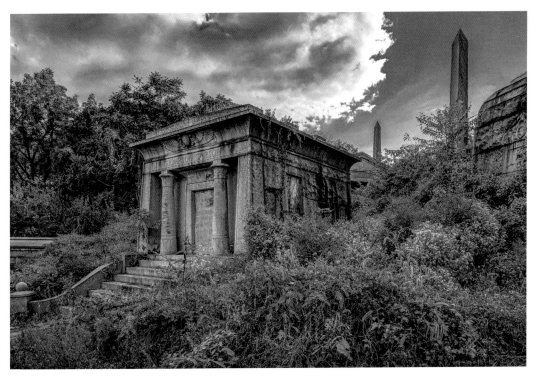

MAUSOLEUM CRYPT: Mausoleum Hill is on the Yeadon side of the cemetery.

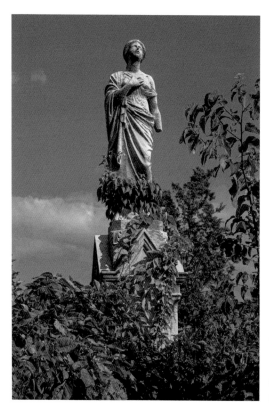

MONUMENT: Mount Moriah was founded in 1855 and contrasted with Philadelphia's other large nineteenth-century graveyards such as Laurel Hill and Woodlands, in that Mount Moriah was accessible by streetcar and permitted interments of African Americans, Muslims, and Jews.

MONUMENT: In the 1870s, an African American man, Henry Jones, purchased a Mount Moriah burial lot. After Jones's death, cemetery authorities refused to bury him onsite based on race. A lawsuit filed in 1876 against the Mount Moriah Cemetery Association had the Supreme Court rule that Jones held rights to be interred in the cemetery.

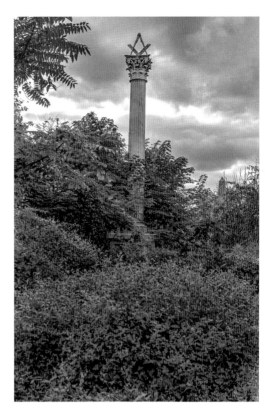

▲ **THE SCHNIDER MONUMENT AT MASON'S CIRCLE:** The 30-foot-high Corinthian column topped by the Masonic square and compass honors William B. Schnider, the Grand Tyler of Pennsylvania's Central Grand Lodge.

▼ **MAUSOLEUM HILL ON YEADON SIDE:** Philadelphia and Yeadon share almost equal shares of the cemetery with Cobbs Creek separating the two sides.

▼ **DUSK:** The remains of Betsy Ross and her third husband, John Claypoole, were moved from Mount Moriah to the Betsy Ross House. The Daughters of the American Revolution erected a flagpole on the site of her grave to honor Ross's memory.

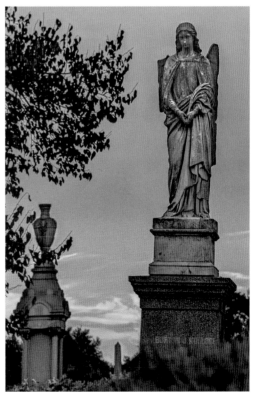

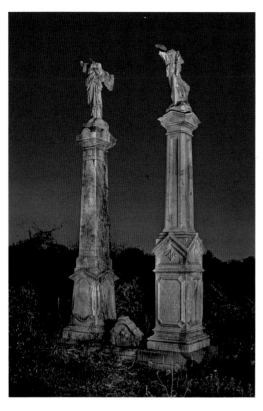

LIGHT PAINTED HEADLESS ANGELS:
The Friends of Mount Moriah Cemetery presented
a plan to the Philadelphia Planning Commission,
which would convert the cemetery into a nature
sanctuary.

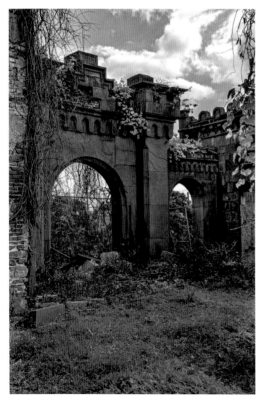

GATEHOUSE: In 2015, the Pennsylvania Historic
and Museum Commission announced Mount
Moriah's eligibility for a listing on the National
Register of Historic Places, subject to review by
the NRHP.

6

LEAVE A COLORFUL MARK ON THE WORLD:
GRAFFITI UNDERGROUND

Of late, ominous warnings of rising crime and assault are assigned to a unique site in Philadelphia, and one I visited a few years ago. Increased police patrols and immediate arrests for trespassing are now the norms at this magical place. When I meandered toward Pier 18 of Port Richmond's Coal Piers ("Piers"), I did not have a sense of my safety in jeopardy, despite pathways littered with broken glass, empty spray paint cans, and colorful splashes of "art" visible on practically every hard surface. Of course, an urban explorer would find such an environment inviting. When I surveyed the Piers, there was much activity on the waterfront property—people walking their dogs along the eroded pathways, teenagers jumping into the murky water, solo adults fishing for a catch-of-the-day, and the graffiti artists working their craftsmanship onto the stately concrete Stonehenge-like Piers.

I loved photographing this place because I gravitate to mathematical symmetry in architecture, and this structure certainly had the repeating proportioned arches that seemed to wander into infinity. I am not a fan of graffiti attached to abandonments, but in this case, I loved the graffiti artists' vibrant colors against the imposing but drab stone canvas of the Piers. The Piers as a surreptitious graffiti venue originated in the early 1970s, hence why the location is known as the Graffiti Underground. Before the concrete maze of arcs at the Piers was a context for covert painters; however, this odd architectural configuration on the edge of Philadelphia waters was dedicated to serving Philadelphia's coal industry from the eighteenth century to the mid-1970s.

The discovery of anthracite coal in Eastern Pennsylvania prompted the construction of the Schuylkill Canal and later, Port Richmond's Piers. The Piers acted as the handover point for coal from Pennsylvania's coalmines to global market destinations. In the late 1800s, the Piers held twenty-one shipping docks, with a summative length of 15,000 feet. Train cars loaded with coal at the mines

were brought directly to the Piers, with coal dumped into Pier chutes by way of a door in the train car floors, and proceeding to transfer to steamships for delivery to international trade sectors.

The coal missions at the Piers, however, were fleeting. When natural gas and oil replaced coal as the preferred fuel source during the mid-twentieth century, the Piers closed. At the time of coal operations cessation, Conrail owned the railroad that served the Piers, and in 1976, Conrail removed most of the train tracks at the Piers. Conrail still owns the Piers property and is cooperating with the Delaware Waterfront Corporation to sell some of the Piers property for repurposing as a public park—a more polished version of a park than what it appeared to be when I visited the site.

Revitalization studies for the Piers are in progress. The Piers, although in an urban sector, are somewhat isolated and apart from the bustle of inner city Philadelphia, yet seated on an oddly beautiful waterfront perch. Within the past few years, Conrail increased security patrols of the property, and police are enforcing no trespassing ordinances, so urban explorers should heed this warning. I am so pleased, however, for the opportunity to visit this peculiarly lovely artist's haven holding color and unusual architectural stone bones.

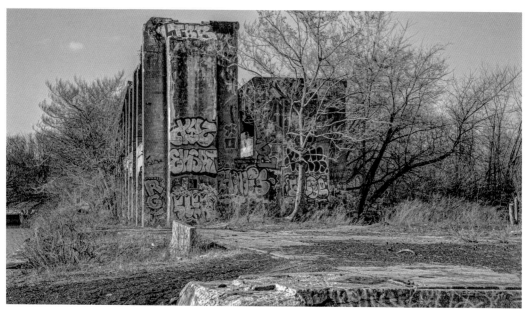

GRAFFITI UNDERGROUND COAL PIER ("PIERS"): The Piers opened in the late nineteenth century as a coal loading dock, and closed in 1991.

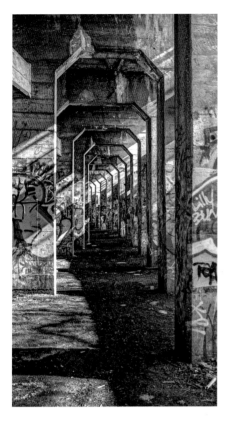

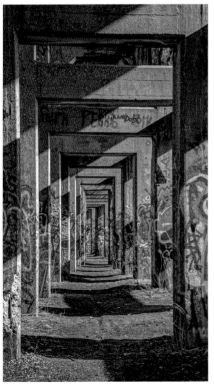

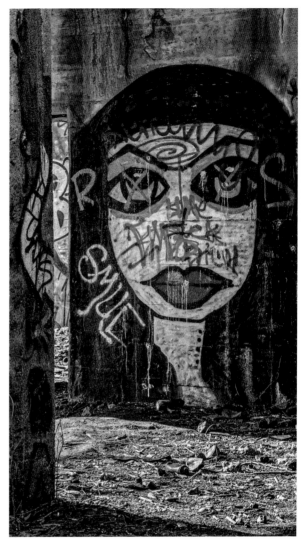

▲ **ENDLESS SYMMETRY:** The slowly decaying, but colorful structure that juts into the Delaware River in Port Richmond is on private property, owned by Conrail.

▲ **COLORFUL CONCRETE ARCHES:** In the years following the closure of the Piers, the site became the gathering spot for graffiti artists.

▼ **COAL PIERS ART:** Plans to revitalize the Philadelphia riverfront into a public park every half-mile along the Delaware River will include the Piers, but the planning is still in the early stages of development.

7

THE HEART OF DELIGHT:
IREM SHRINERS TEMPLE

Frequently, when one hears discussions of the Shriners, one recalls an image of bright red Fezes, colorful, lively parades with marching bands, vibrant costumes, clowns, and tiny cars. Additionally, Shriners are famous for their official philanthropy, especially the Shriners Hospital for Children, often referred to as the heart and soul of the Shrine. Shriners hold many fundraising events to support themselves and the hospitals, and the Shrine Circus is a popular event with 100 percent of the proceeds presented to Shriners Hospitals. The Shriners consider themselves an international association based on fun, the principles of brotherly love, and camaraderie.

When first viewing the majestic Irem Shriners Temple in Wilkes-Barre, one cannot help but see a beautiful example of unusual Moorish Middle Eastern architecture, especially evident in its stately green dome and striking minarets. The beauty does not end with the exterior, as the interior is just as dramatic and stunning.

Vacant since the 1990s, the Irem Temple served the Wilkes-Barre community for many decades. Construction of the Irem Temple commenced in 1907, with dedication in 1908. The colorful auditorium holds a massive lacey stained glass skylight, unlike any other in the United States. This Temple held the rituals, social events, and entertainment for both the Shriners and various Eastern Pennsylvania groups within the region. Broadway-type productions, circus events, conventions, weddings, concerts, and graduations were Irem Temple staples before it closed its doors.

The Irem Temple Restoration Group acquired the Temple in 2005 with plans to restore it. The Restoration Group recently received a $100,000 grant from the Local Share Account funding, a Department of Community and Economic Development program funded by proceeds from the nearby Mohegan Sun Casino in the Poconos. The local Chamber of Commerce also provided some funding, and fundraisers assist with this renewal endeavor. Long-term plans include having the Temple reintroduced back into the public for business and community use and once again becoming a heart of delight.

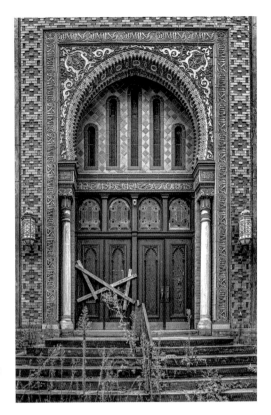

MAIN ENTRANCE DOOR: Construction of the Irem Temple commenced in 1907 and completed in 1908, at a cost of $230,000.

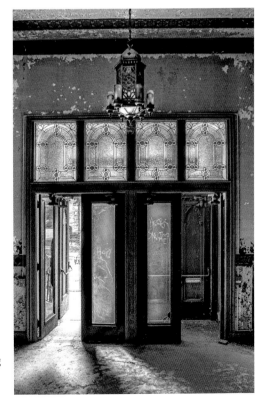

LOBBY: The Irem Temple's auditorium held seating for 1375, and the facility also provided banquet accommodations for 1480.

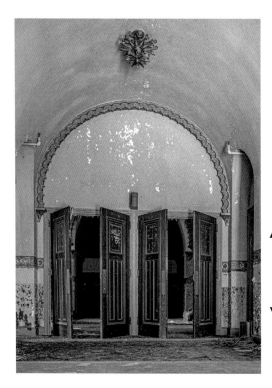

▲ **ENTRANCE TO AUDITORIUM:** In 1931, not only was a stage added to the auditorium, but also a sloped floor replaced the flat floor.

▼ **STAINED-GLASS SKYLIGHT IN AUDITORIUM:** From the beginning of the Shriners organization, the Shrine Temple was intentionally designed to be a joyful venue.

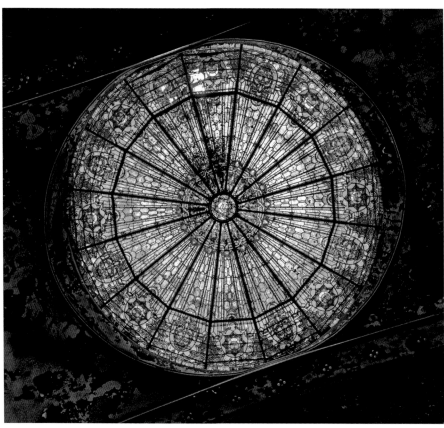

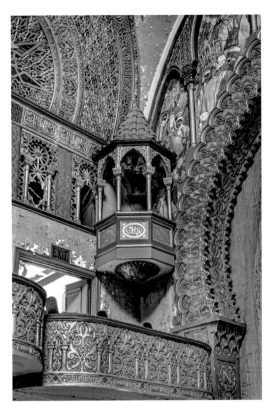

AUDITORIUM UPPER TIER: All Shriners are Freemasons, but not all Freemasons are Shriners. Shrine Temples are very large, and only a few exist in any given state, consequently, each temple draws on dozens or even hundreds of Masonic lodges for its membership.

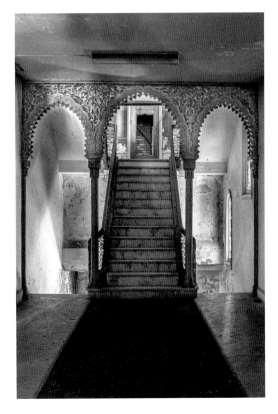

STAIRWELL: The Shriners built their dedicated buildings during times of prosperity and were generally designed with Middle Eastern architectural details.

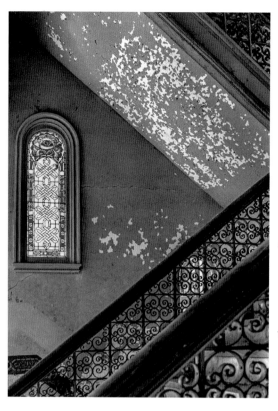

▲ **STAIRCASE AND STAINED-GLASS WINDOW:** The Shrine is an international fraternity of approximately 1 million members who belong to Shrine Temples across the globe.

▼ **LOUNGE:** Worn for decades, the Shriners' red fez with a black tassel derives its name from the place where the fez was first manufactured—the holy city of Fez, Morocco.

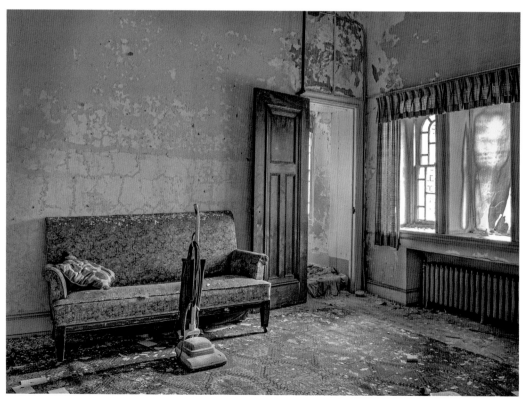

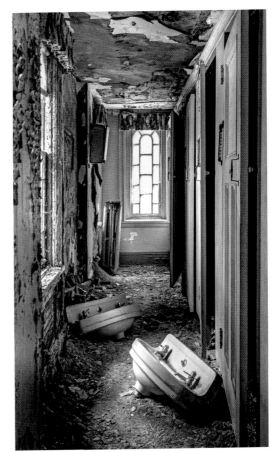

▲ **BATHROOM:** The Shrine Temple supported various charities from its beginnings, but in 1920, the organization voted to adopt its official philanthropy dedicated to offering free orthopedic medical care to children in need. The first Shriners Hospital appeared in Shreveport, Louisiana, in 1922.

▼ **THIRD-FLOOR BALLROOM:** In 2005, the Wilkes-Barre Chamber of Commerce purchased the Irem Temple for just under $1 million, but the site still sits in an abandoned state.

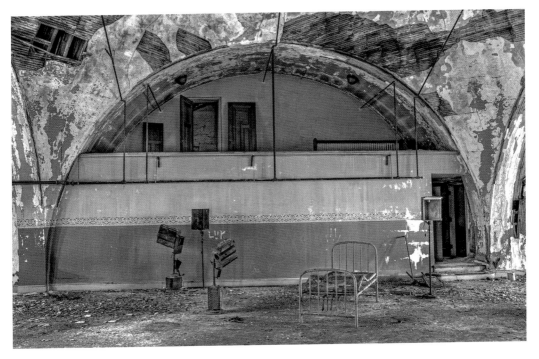

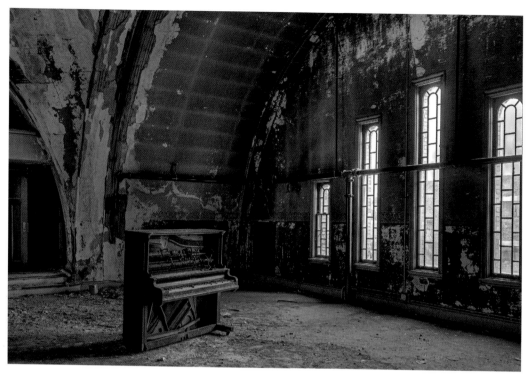

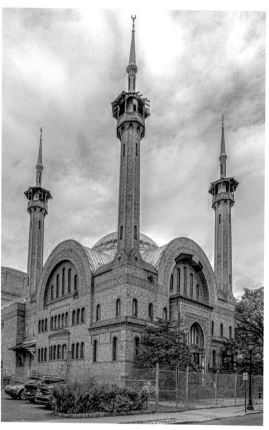

▲ **THIRD-FLOOR BALLROOM:** While the Irem Temple sat in an abandoned state, scrappers and vandals broke windows and removed brass railings and copper wiring.

▼ **IREM TEMPLE EXTERIOR:** The Irem Temple Restoration Group is making efforts to restore the site. Engineering studies indicate that $8–$14 million is needed for restoration. Work is scheduled for interior cleaning and repair of the roof and minarets.

8

LIFE AFTER COAL:
CLOTHING FACTORY

Coal was once an integral cog for Pennsylvania commerce success and was an economic driver in the American Industrial Revolution in the eighteenth century. Pennsylvania's industrial centers burgeoned because of coal, as it provided the natural resource blood for the mechanization of Pennsylvania's manufacturing works. In the heart of Pennsylvania's anthracite region, is an abandoned clothing manufacturing company, formerly a silk mill at its opening in 1904, but later dedicated to the production of children's clothing, including dresses for the Cinderella Label, promoted by Shirley Temple.

The coal industry supported the clothing company, as it employed the daughters and wives of the coal miners. At the height of its production in 1946, the factory employed 500. After World War II, though, the mines contracted and eventually closed with the reduction of coal demand. Accordingly, local manufacturing companies in the coal communities, such as this clothing manufacturer, shadowed this downturn and shuttered their facilities. Adding to this were changes in clothing preferences from dresses to more informal attire as well as competition from the rise in international textile manufacturing.

The stresses within the garment industry were too much to endure, and this clothing manufacturer folded in 1988. Concurrently, a group of former factory employees acquired the shop machinery and created the Kiddie Kloes apparel label, but it was not a workable plan and thus closed its doors in 1996. Since this time, the building, along with its contents, suffers the effects of decay and time. The factory is in poor structural condition from several floods and vandalism. In 2017, the building joined the Pennsylvania At Risk list, and some local residents, including some artists, hope to restore it—an overwhelming, but grand objective.

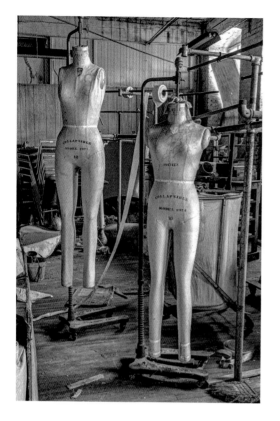

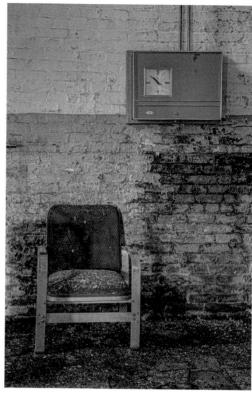

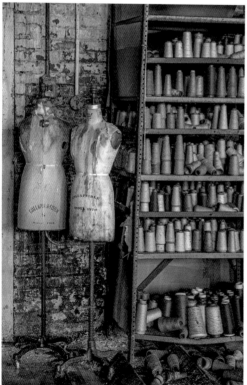

▲ **DRESS FORMS:** Dress forms in the sixteenth and seventeenth centuries were made of *papier-mâché*, wood, or wicker. Later, dress forms were made with fabric or wires for a more structured form.

▲ **MID-TWENTIETH-CENTURY CLOCK AND CHAIR:** The clothing factory was built in 1904 and operated as a silk processing business for nearly thirty years before filing for bankruptcy after the depression.

▼ **DRESS FORMS AND SPOOLS OF THREAD:** The demand for silk plummeted with the introduction of rayon and was a contributing factor for the company's post-depression bankruptcy filing.

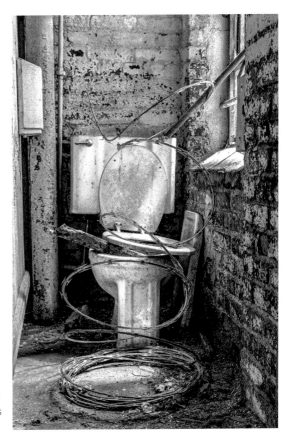

▲ BATHROOM WRAPPED IN RAZOR WIRE:
Perhaps this is one method for the prevention of entry into the facility by vandals, scrappers, and urban explorers.

▼ REMNANTS FROM AN OFFICE:
The well-established transportation systems in anthracite coal towns were appealing locations for industry, especially textile facilities.

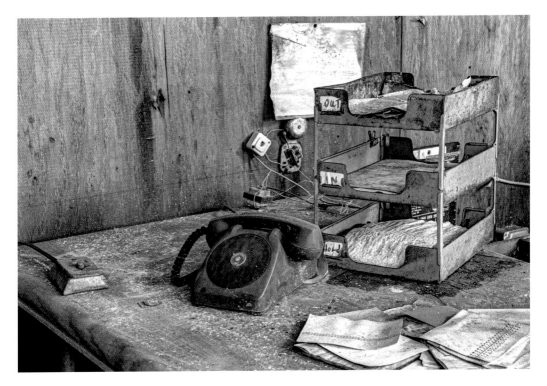

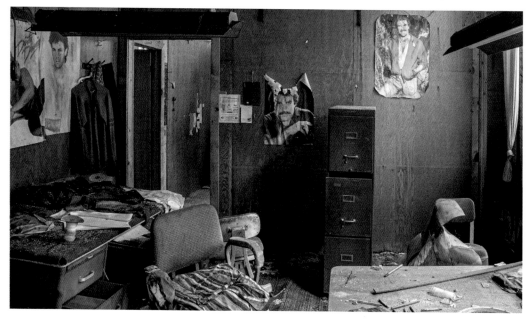

OFFICE: In 1935, the shop transformed from a silk throwing mill to a clothing factory.

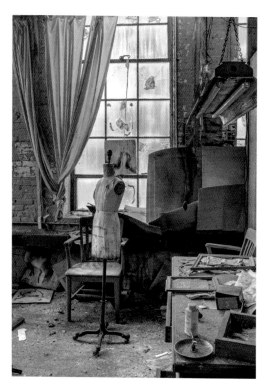

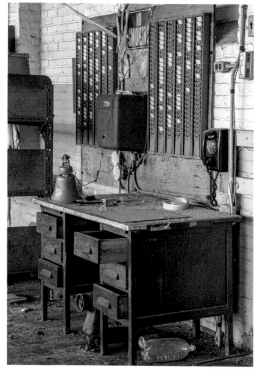

◄ **OFFICE WITH DRESS FORM:** A Philadelphia based textile company assumed the clothing factory in 1935 and was America's largest manufacturer of girls' dresses.

▶ **DESK AND TIME CLOCK:** The Cinderella dress label was the factory's largest clothing line from the 1930s to the 1950s. The Cinderella line, endorsed by Shirley Temple, was introduced in 1914.

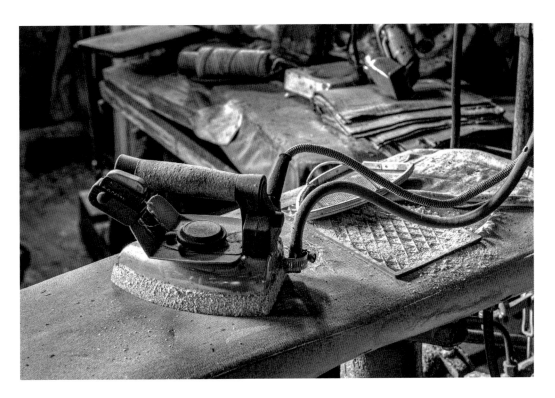

▲ VINTAGE IRON: At its peak of production in 1946, the factory employed 500.

▼ STEAM PRESS: A steam press consists of a buck and head. Fabric is placed on the buck, and the head is lowered on the buck along with the application of heat and pressure for the press.

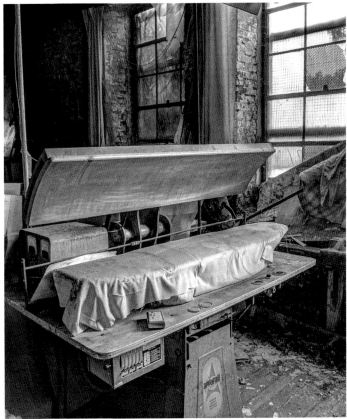

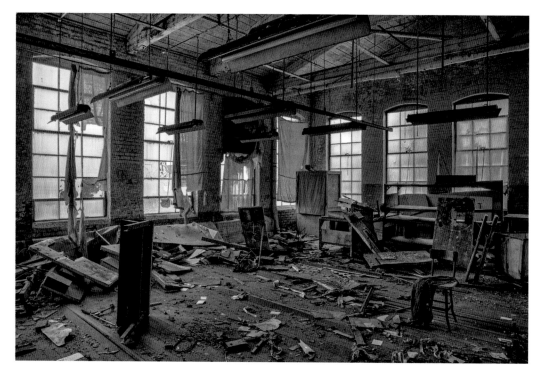

FACTORY: Because of a significant change in consumer preferences for children's apparel, and other reasons, the company filed for bankruptcy in 1974.

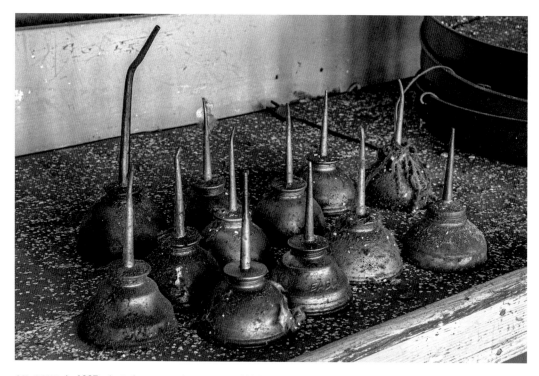

OIL CANS: In 1987, ninety former employees created Kiddie Kloes, Inc. and attempted to manufacture another line of children's clothes, but it was not successful, and the factory permanently closed in the 1990s.

9

A PRISON BREAK:
EASTERN STATE PENITENTIARY

In the late eighteenth century, Benjamin Franklin and several Quaker leaders believed that total isolation and silence for misdeeds would lead to penitence; hence, the term penitentiary emerged. Born of this philosophy, Eastern State Penitentiary ("ESP") arose. ESP, designed by John Haviland, opened its prison doors on October 25, 1829, and is considered the world's first true penitentiary. ESP's innovative system of confinement was coined the Pennsylvania System and holds to solitary incarceration as the method of prisoner management. Further, the ESP interior architectural design is associated with penance for the promotion of religious inspiration. ESP's cellblock corridors hold church-like characteristics in that the prison passageways feature high-arched and vaulted ceilings. The cells had lofty-domed ceilings too and contained a single glass skylight as a representation of the "eye of God," implying that God always observes an inmate. Additionally, the doors to the cells were small, and prisoners had to bow upon entry to their cell.

Architect Haviland's floor plan also consisted of a hub and spoke design, which included an octagonal epicenter connected by corridors to seven extended single-story cellblocks. The cellblocks, technically advanced for its time, integrated hot water heating, a water tap, toilet, and individual exercise yards.

Although not followed for decades, by 1913, ESP administrators terminated the practices associated with the Pennsylvania System. The Quakers' support of long-term solitary confinement soon recognized this custom as a failure, and later, the Quakers apologized for their advocacy of this type of incarceration as such incarceration often led to mental health problems and, at times, insanity. By the 1950s, problems with prisoner management and overcrowding in concert with mental health concerns, prompted a relaxation of the rules concerning isolation philosophy. Overcrowding, though, continued and drove the construction of more cellblocks. With these cellblock additions, however, more than one inmate occupied a cell.

Despite ESP's failure at rehabilitation with the use of solitary confinement, isolationist imprisonment continues to be a practice on any particular day, with more than 60,000 prisoners held in seclusion for twenty-three hours per day and with little or no access to the outdoors. ESP closed in 1971, but the United States still has a long road ahead for the realization of proper rehabilitation methods, given its continued practice of solitary confinement.

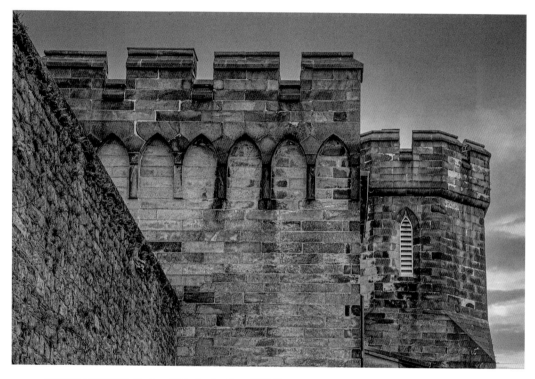

PRISON EXTERIOR: Eastern State Penitentiary ("ESP") operated from 1829 to 1971.

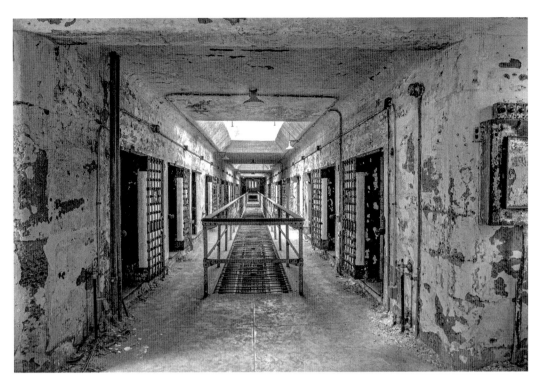

ELEVATED CELLBLOCK: ESP is a United States National Historic Landmark.

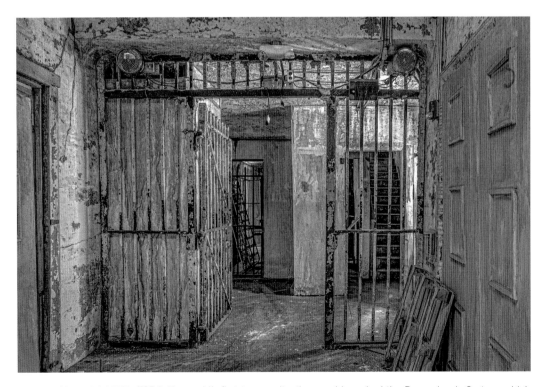

STORAGE AREA: ESP is the world's first true penitentiary, and launched the Pennsylvania System, which promoted solitary incarceration as a form of rehabilitation.

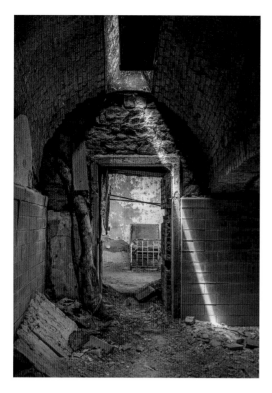

▲ MEDICAL WING: The Pennsylvania System of confinement required the warden to visit each inmate on a daily basis, and the guards visited inmates three times a day.

▼ SURGERY THEATER: ESP's radial floor plan and system of solitary incarceration was the standard for over 300 prisons across the globe.

▼ INFIRMARY: In the prison's original plan, although ESP inmates were secluded from others, they were able to enter a small exercise yard attached to the back of the cell. The prison cell had a small opening on the corridor side, and it was only wide enough for the passage of meals.

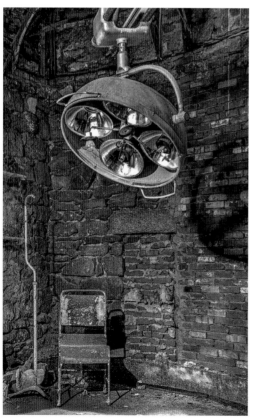

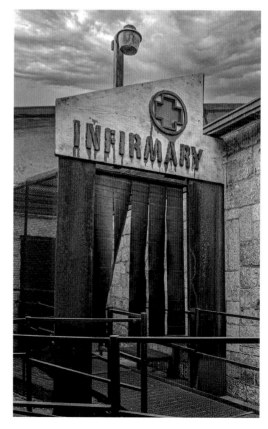

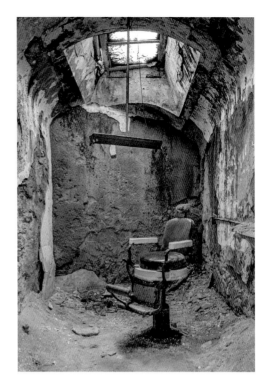

BARBER CHAIR: The original cellblock design was impractical, and construction plans changed to have cell access through the cellblock corridor via cell metal doors covered with heavy wooden sliding doors for noise filtration.

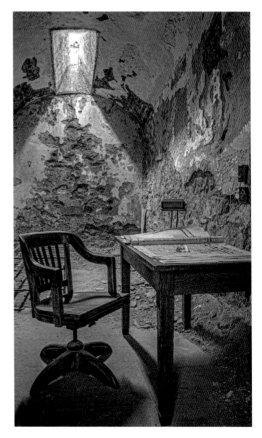

CELL: The cell doors were small, and some thought this would provide exit obstacles and, thus, abate guard attacks, while others believed the small doors forced prisoners to bow while entering their cell—a principle of penance.

▲ **EXTERIOR DOOR TO CELLBLOCK:** In the early stages of the prison, the exercise yard was enclosed with high stone walls. Exercise time was coordinated, so no two inmates next to each other would be in the exercise area at the same time.

▼ **KITCHEN:** During ESPs early stages, prisoners were allowed to garden and keep pets in their exercise yards.

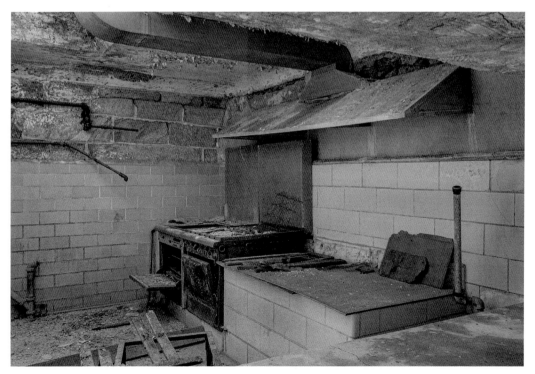

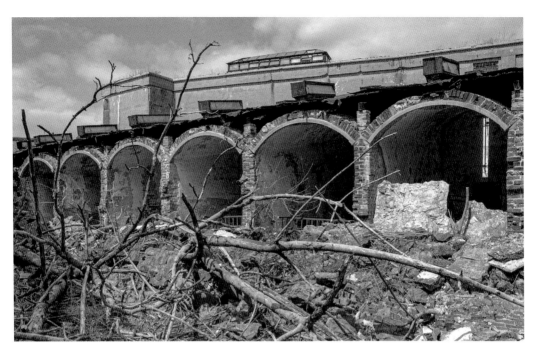

VIEW OF DEATH ROW CELLBLOCK FROM YARD: The prison closed in 1971, and many prisoners and guards transferred to Graterford Prison, about 30 miles northwest of ESP.

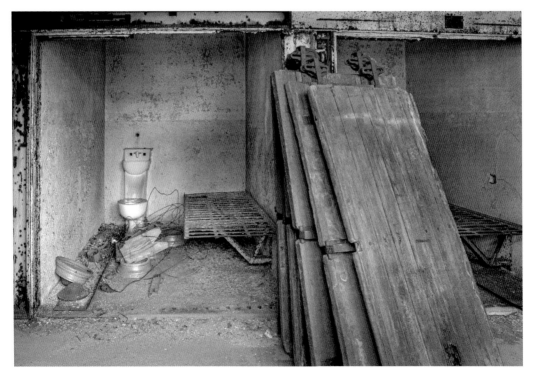

DEATH ROW CELLS: Cells were progressive for their time during ESP's early years, and included a faucet with running water over a flush toilet as well as wall piping to allow for heat. Toilets were remotely flushed two times per week by cellblock guards.

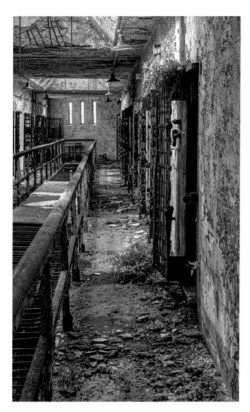

ELEVATED CELLBLOCK: From 1971 to the late 1980s, vegetation and trees grew in cellblocks and within the prison interior. The prison also became a home to many feral cats. In 1994, ESP opened to the public for history-oriented tours.

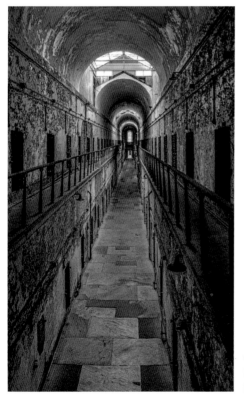

CELLBLOCK: Prominent ESP visitors included Charles Dickens and Alexis de Tocqueville, and noteworthy inmates included Willie Sutton and Al Capone.

10

FACTORY OF LOST DREAMS:
SCRANTON LACE

Imagine going to your place of employment on any given day, only to hear the vice president of your company declare mid-shift that the facility is closed, effective immediately. In 2002, this incident was a reality for the employees of the Scranton Lace Company ("Scranton Lace"). At once, the enormous Nottingham Lace looms stopped mid-stream of production. When I visited Scranton Lace thirteen years after closure, a Nottingham Lace loom still held the lace pattern, thread, and partially finished product after the final swipe of the loom's off-switch. For more than 100 years, Scranton Lace was an economic force in this Eastern Pennsylvania region, and when the factory abruptly shuttered, the area experienced the immediate and prolonged pain of this action.

Scranton Lace, known as Scranton Lace Curtain Manufacturing Company on its inaugural day of business in 1890, incorporated in 1907. Scranton Lace Curtain Manufacturing Company converted to Scranton Lace Company in 1958. From 1916 until the closing in 2002, Scranton Lace was the first and most significant United States producer of Nottingham Lace. The large Nottingham Lace looms, manufactured in England, were two and one-half stories tall, and 50 feet wide. Several other types of looms also fabricated in England claimed Scranton Lace as home too. Scranton Lace produced tablecloths, napkins, valances and shower curtains as well as other items. During the World War II years, Scranton Lace joined with Victory Parachutes and Sweeney Brothers to manufacture parachutes and camouflage netting in concert with the war effort.

Scranton Lace provided an oasis of services for its employees. The facility included a theater, bowling alley, gymnasium, infirmary, barbershop, kitchen and dining hall, and a host of other amenities. At the height in production in the 1950s, Scranton Lace employed 1,400 people. Scranton Lace's financial robustness was snappishly thrust into unsettled financial waters in the 1950s, though, when the company assumed questionable business ventures concerning Hal Roach Studios as well as associations with America's emerging television business sector.

In 2019, the planning commission in Scranton advanced a proposal to demolish parts of the abandoned Scranton Lace facility and replace it with the installation of a residential and mixed-use complex known as Laceworks Village. The plans include the preservation of Scranton Lace's historic clock tower featuring a Meneely cast iron bell, but much of the once-proud factory is gone.

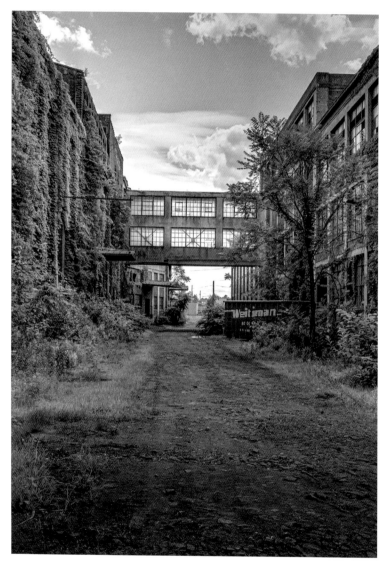

EXTERIOR: Scranton Lace Corporation ("Scranton Lace") was the world leader in the production of Nottingham Lace and also manufactured tablecloths, shower curtains, napkins, valances and other articles, including vinyl items. Two massive buildings were connected with an elevated walkway and long courtyard.

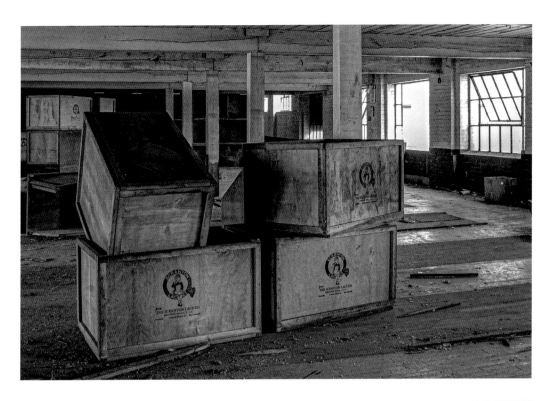

▲ **SCRANTON LACE SHIPPING CONTAINERS:** In the 1940s, Scranton Lace joined Victory Parachutes and Sweeney Bros. to manufacture parachutes and camouflage netting.

▼ **ROOM OF LACE PATTERNS:** Large sheets holding punched patterns were inserted into the lace looms for the manufacture of lace items.

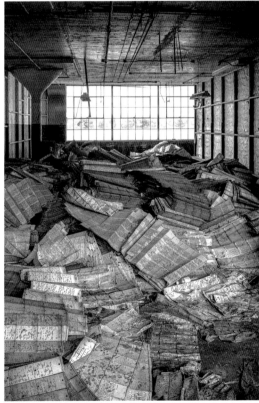

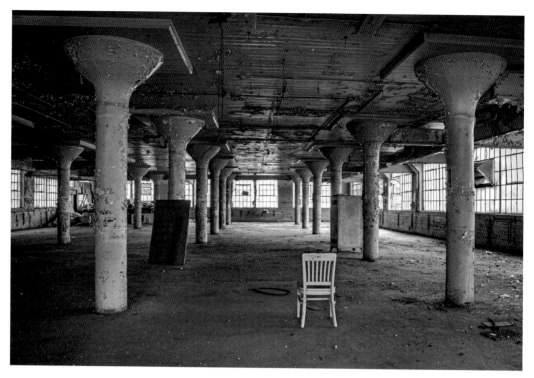

WAREHOUSE: In 2012, Scranton Lace joined the National Register of Historic Places, but in 2019, significant sections of Scranton Lace underwent demolition.

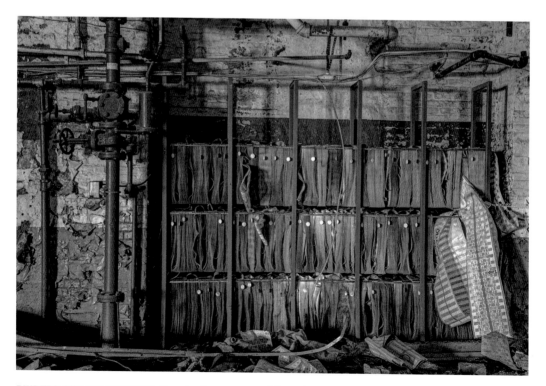

BINDERS OF LACE PATTERNS: Scranton Lace was one of the region's major employers but closed in 2002.

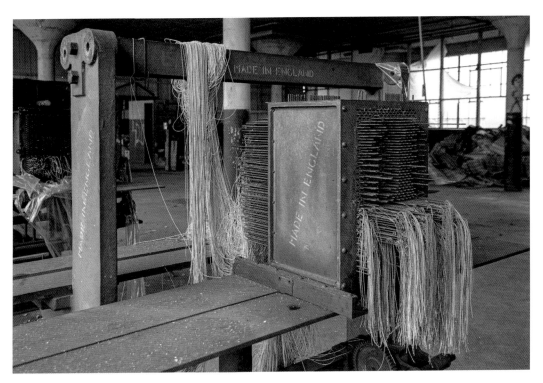

LOOM: In 2002, Scranton Lace employees were told, mid-shift, that the factory was closing immediately.

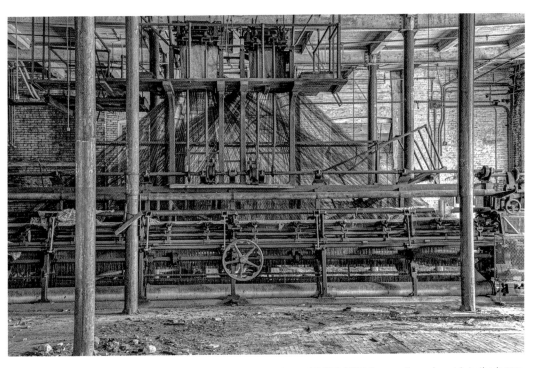

NOTTINGHAM LACE LOOM HOLDING INCOMPLETED LACE PROJECT: Lace patterns insert into the looms, and the pattern holes allow the loom needle to carry a thread through and also pick up one of the warp threads stretched underneath. The loom is almost three stories high, 50 feet long, and weighs over 20 tons.

EMPLOYEE BOWLING ALLEY: A four-lane bowling alley still held some pins and bowling balls. Old bowling scorecards and bowling shoes were scattered about the area.

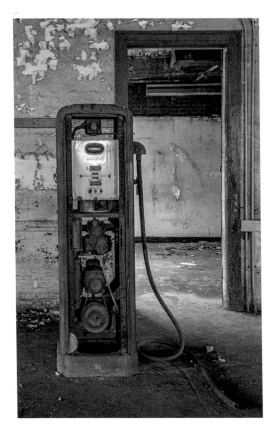

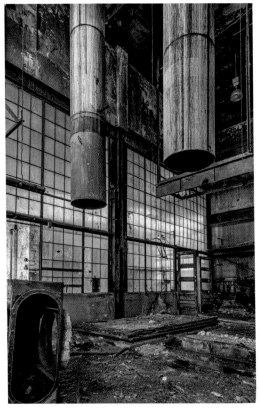

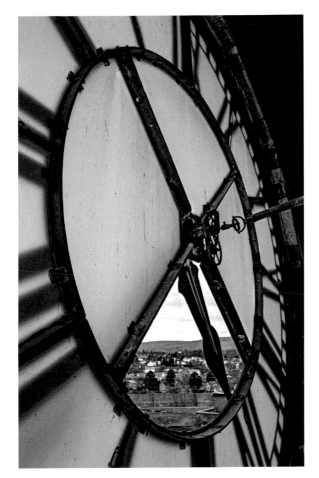

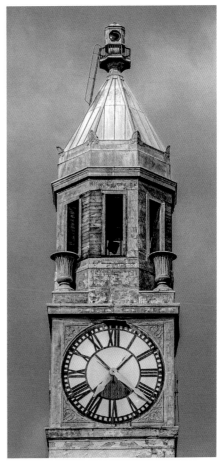

◄ **SCRANTON VIEW FROM CLOCKTOWER:** As computerized looms replaced the manual looms, Scranton Lace felt the technology pinch and shuttered their doors like so many other craft-style textile manufacturers.

► **CLOCK TOWER:** The Scranton Lace clock tower is a city landmark. The clock tower holds a large Meneely cast iron bell from the early twentieth century. The redevelopment of the site intends to keep the clock tower and bell.

Opposite page

◄ **VINTAGE GAS PUMP IN WAREHOUSE:** At one time, Scranton Lace maintained a coal mine and cotton field to support its factory operations.

► **POWERHOUSE:** In its latter years of operation, Scranton Lace employee staff dwindled to about fifty, with annual sales about $6 million.

11

BENEATH THE BEAM:
BETHLEHEM STEEL COMPANY

Well we're living here in Allentown. And they're closing all the factories down.
Out in Bethlehem they're killing time. Filling out forms. Standing in line.
Lyrics to Billy Joel's song "Allentown," 1982

As I grew up in Allentown, I was always aware of the powerful presence of my neighbor, the then mighty Bethlehem Steel Company. Bethlehem is a quiet, modest borough spanning the Lehigh River, and held a different view from the interstate highway parallel to the River in what seems like only a few short decades ago. At the end of the twentieth century, smoke billowed over the Bethlehem horizon, produced by round-the-clock steel blast furnaces and stacks. The sky would glow with a ginger radiance. The constant chatter and tremble of active heavy machinery would be omnipresent. For the proud town of Bethlehem, this din was the sound of success and fortune. I also remember my father's prescience during the 1960s as he exclaimed over and over again that "the Steel" better innovate and modernize their plants, or else they will be nothing short of rusty hulks in twenty years. Indeed, Billy Joel's "Allentown" spoke of the unique set of challenges for the cities and towns of the manufacturing heartland in the Northeast as well as other rust belt regions. By 2001, the toots from the factory whistles signaling shift changes no longer shriek, and the growl of a blast furnace is just a memory. The Bethlehem night sky is now black, instead of holding to a draping of orange luminosity. My father's wise words from the early 1960s were undeniably prophetic.

Big steel production accelerated during and shortly after World War II. Bethlehem Steel, along with its competitors in the Western Pennsylvania and Ohio Rust Belt regions, helped our nation win wars, but also built our cities and infrastructure. Bethlehem Steel Company was America's second-largest steel and shipbuilding company when it began operations in 1904, even though its roots date to 1857. During the war eras, Bethlehem Steel's profits were steady, and the demand for steel was high. Domestic steel exports outnumbered imports five to one, and the

need for big steel continued after World War II when the demand for automobiles and consumer appliance products drove sales to 2.1 billion in 1953—the golden era for Bethlehem Steel. Both Bethlehem Steel executives and workers enjoyed the benefits of the national and international demand for steel.

From 1910 until 1970, Bethlehem Steel fabricated the structural steel framework for most of New York City's skyscrapers, including the Waldorf Astoria, Chrysler Building, Time-Life Building, Madison Square Garden, and a host of other lower Manhattan and Wall Street skyscrapers. In the 1960s, Bethlehem Steel was financially vulnerable in additional ways that were not so obvious, such as labor strikes as ancillary variables having a hand in the unstable steel equation of profit. National strikes allowed the steelworkers to have the power to demand higher wages but also permitted the door to open to foreign steel and its modern steel technology, as well as prompting the rise in domestic mini steel mills that would ultimately poach many of Bethlehem Steel's customers. By the 1980s, the Bethlehem Steel Company possessed outmoded production plants, incurred steep labor costs, faced rising foreign and domestic competition, and experienced eroded profits at a time when the steel industry experienced the worst downturn in fifty years. It seems all active actors involved in the steel industry were blinded to steel's future course of development until it was too late for action to reverse the downward economic steel spiral.

Fortunately, and unlike some similar steel towns in the Rust Belt regions, the loss of the Bethlehem Steel facility was not a fatal blow to the city of Bethlehem. In fact, in the years following Bethlehem Steel's shutdown, the city healed and grew, due to practical municipal development, as well as a good time-honored dash of good luck. With a casino occupying a portion of the Bethlehem Steel footprint, the iconic blast furnaces, now referred to as the Steel Stacks, present a beautiful illuminated backdrop for entertainment venues in the foreground. Furthermore, there are ongoing and significant efforts to safeguard the steel heritage of much of the community, not in a heavy industry production sense, but toward a needed historical preservation sense.

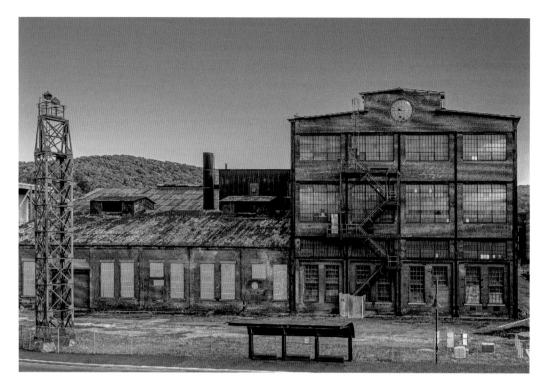

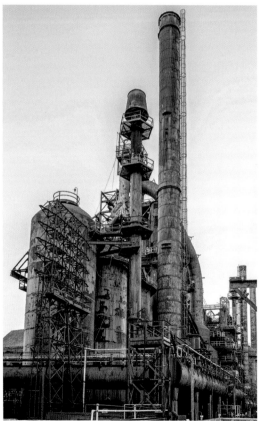

▲ **CENTRAL TOOL SHOP AND ANNEX:**
The Bethlehem Steel Company was
established in 1899.

▼ **BLAST FURNACE:** The blast furnace reduced
iron ore to metallic pig iron and handled 800
to 33,000 tons of iron per day. Most of this
iron was processed into steel.

OPPOSITE PAGE

◄ **REMNANTS IN CENTRAL STORAGE
FACILITY:** The Bethlehem beam or I-Beam
became the industry standard for skyscraper
construction.

► **1941 WHITCOMB LOCOMOTIVE:**
The locomotive was last used in Bethlehem
Steel's electric furnace smelt shop, where
it moved four-wheel railroad cars known as
charging buggies to the charging floor. The
train would deliver scrap metals and other
materials to the furnaces.

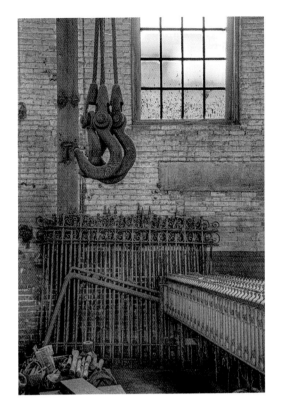

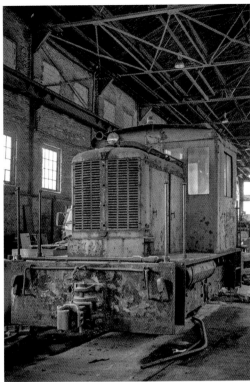

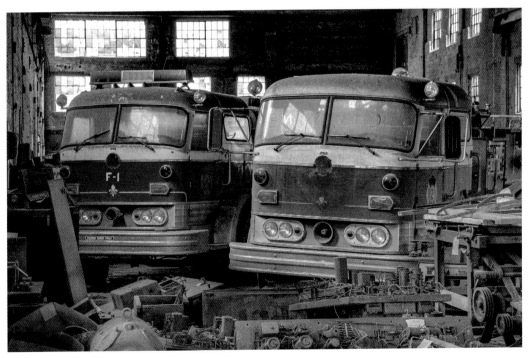

MACK MODEL C SERIES FIRE ENGINES IN WAREHOUSE: The Mack C-series was a custom chassis manufactured by the Mack Trucks Fire Apparatus Division. Over 1,000 Model C fire trucks were manufactured between 1957 and 1967.

12

ELEGANCE OF THE PAST:
LANSDOWNE THEATER

O pulent, plush, large-capacity single-screen movie theaters were once fixtures on so many Main Streets in the United States. Between the 1920s and 1950s, movie studios in Hollywood constructed ornate movie houses in America's cities. Paramount, MGM, Warner Brothers, and RKO vied to build the most magnificent theater palaces for the staging of their epic cinematic masterpieces. Theaters that seated thousands often embraced décor in several fancied styles such as Art Nouveau, Art Deco, Egyptian, Gothic, or in the style of the photographic subject of this chapter, Lansdowne Theater's Moorish Revival.

In 1948, though, the United States Supreme Court held that the major Hollywood studio monopoly of theater chains violated the Sherman Antitrust Act. The Court ruling launched the end of the era of the film palace design, as Hollywood studios were ordered to liquidate or shutter their theater holdings. Additionally, television and the suburbanization of America negatively impacted the robustness of the movie industry.

The town of Lansdowne is seated within the Philadelphia metropolitan area. The Lansdowne Theater closed in 1987 after an electrical fire erupted in the basement. Soon after this, the bank foreclosed on the theater property, but an electrical supply company considered a purchase of the space for warehouse purposes. Matt Schultz, a local Lansdowne citizen, is instrumental in saving Lansdowne from the banality of a warehouse, and fondly remembers his visits to the theater when it was open. Schultz is the executive director of the Historic Lansdowne Theater Corporation, with said corporation instrumental in the development of an $11 million capital project for the restoration of the theater into a venue for live music and community happenings.

Lansdowne, designed by architect William Harold Lee, materialized in 1927, with seating for 1,400, and features intricate hand-painted ceilings, an impressive 270-lamp chandelier in the main auditorium, colorful tiles throughout, and fountains in the front lobby.

Lansdowne joined the National Register of Historic Places in 1986. The Philadelphia region is fortunate to include a group with such enthusiastic interest in the preservation of such an architectural jewel, because Lansdowne Theater now has a second chance at life, and so does the community.

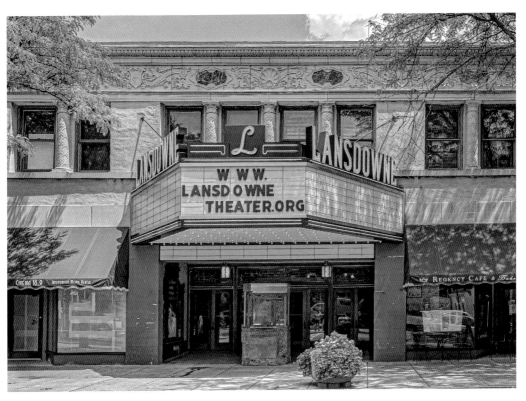

LANSDOWNE THEATER MARQUEE: Lansdowne Theater, constructed in 1927, held a 1,400-seat auditorium.

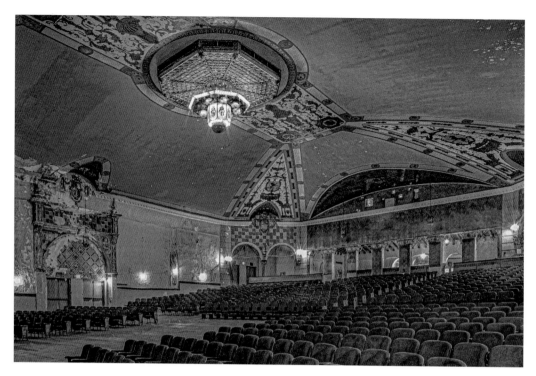

AUDTIORIUM: Designed by theater architect William Harold Lee, Lansdowne Theater was added to the National Register of Historic Places in 1986.

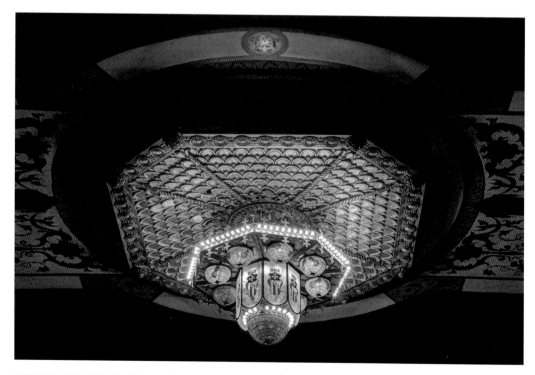

THEATER CHANDELIER: The grand colorful chandelier gracing the auditorium features 270 lamps and is bordered by hand-painted designs on the ceiling.

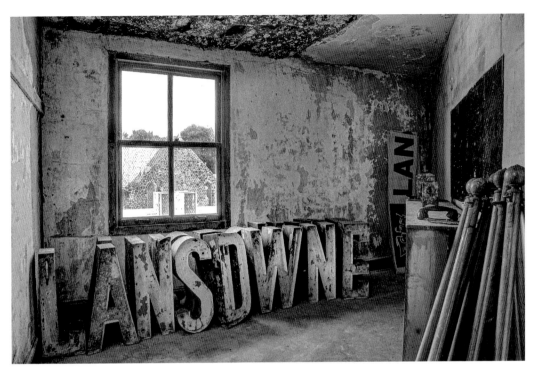

LANSDOWNE SIGN: Lansdowne closed in 1987 after an electrical fire erupted in the basement, and during a showing of Beverly Hill Cops II.

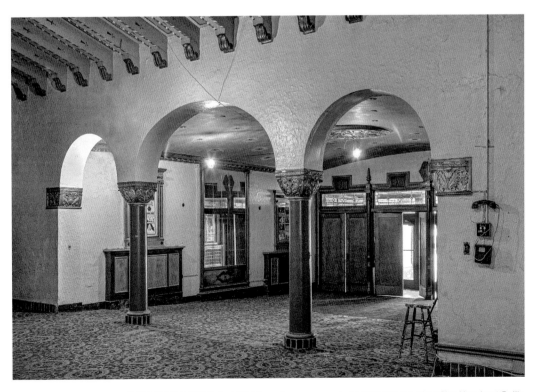

VIEW OF LOBBY FROM AUDITORIUM: In 1927, Lansdowne opened and featured the silent film *Knockout Reilly.*

MARQUEE LETTERS: In 2010, the Historic Lansdowne Corporation held an a cappella fundraising concert in Lansdowne's auditorium. The fundraiser was the first event in the theater since it closed in 1987.

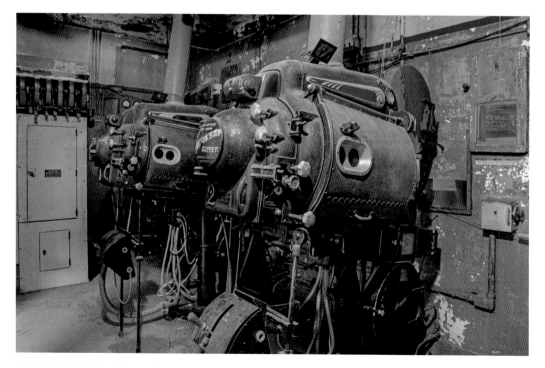

PROJECTION ROOM: While the theater was primarily a movie house, occasionally, live performances appeared on its stage. In 1980, Harry Chapin appeared at a Lansdowne benefit concert for local Congressman Bob Edgar.

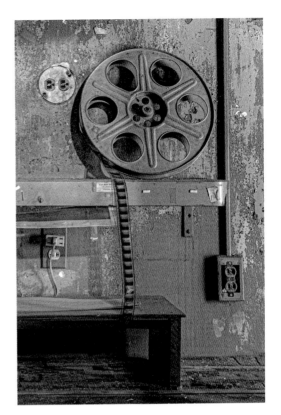

FILM REEL: Lansdowne's second floor included an eighty-seat screening room built in the 1980s. This was the site of the production of the *Moron Movies* shown on Johnny Carson's *Tonight Show*.

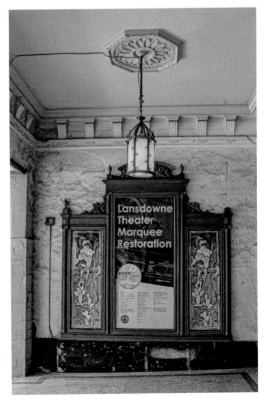

OUTDOOR LOBBY: The 2011 movie *Silver Linings Playbook* featured scenes of the exterior of the Lansdowne Theater.

13

NO LONGER MADE IN AMERICA:
VISCOSE FACTORY

For a portion of the nineteenth century, Great Britain dominated world trade with their manufactured goods. The term "workshop of the world" attached to Britain as the first industrial and consumer-oriented society—forged by the Industrial Revolution. Likewise, the Philadelphia region assimilated such characteristics and was also known as the "workshop of the world" in the early twentieth century. Unfortunately, Philadelphia eventually suffered the same loss of manufacturing firms and jobs that devastated the economies of other domestic and international manufacturing centers.

An Eastern Pennsylvania viscose manufacturing giant was a major economic engine of success within the Philadelphia region in the early twentieth century. For centuries, wool, linen, and cotton were the prevalent fabrics of garments. The wealthy class often purchased garments made of silk, but silk was not a fabric norm for working folk. In 1905, the British Courtaulds Company commercialized a substitute for silk, identified as rayon. Rayon mimicked silk by way of chemically treating cellulose extracted from wood or cotton via a thick liquid called viscose. The viscose liquid seeped through small holes in a template and then dropped into a bath of acid for solidification into rayon.

In 1909, a New York yarn merchant was the chief vendor for Courtaulds's rayon sales in the United States. With booming American sales of rayon, Courtaulds erected a viscose plant 20 miles from Philadelphia, with operations commencing in 1911. The Courtaulds Company also wanted a stable workforce for this new factory, and accordingly, constructed a community of homes and services next to the viscose plant.

During the 1920s, rayon sales flourished in the United States. The first manufactured products were men's socks, and later, lingerie and dresses joined the industrial rayon process. This Eastern Pennsylvania viscose plant held the honor of being the largest manufacturer of rayon in the United States.

With the onset of World War II, an added demand for rayon arose, specifically a need for tire cord, due to rubber shortages in the United States. Rayon strengthened

tire cord and in the process, preserved the limited rubber stock. Even though the shop continued to manufacture tire cord after the war, in short order, however, rayon production was hindered because of the introduction of newer synthetic fibers such as nylon, acrylic, and polyester, with these modern synthetics becoming a consumer preference.

The viscose factory soon ceased rayon production after the war and switched to cellophane film production, another by-product from viscose. Still, this cellophane modification could not save the plant from closure. The rise of foreign textile competition within the garment industry sealed the fate of this viscose company as well as many other textile factories within the United States. Eventually, the viscose factory shut down in 1977, and 580 workers lost their jobs.

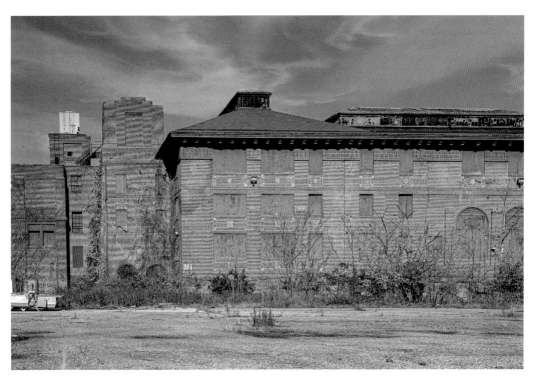

EXTERIOR: Work in a rayon plant was hazardous. The chemicals required for the production of rayon were malodourous and poisonous. Carbon disulfide, used in rayon production, was an especially toxic element.

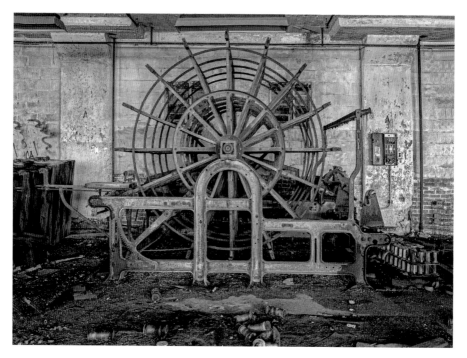

LARGE WOODEN LOOM: The spinning of rayon, or artificial silk as it was known, commenced just before Christmas in 1910 at this first commercially successful rayon plant near Philadelphia.

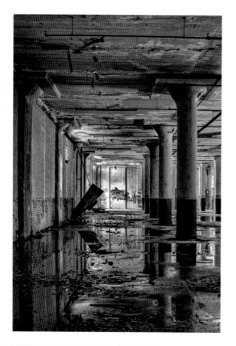

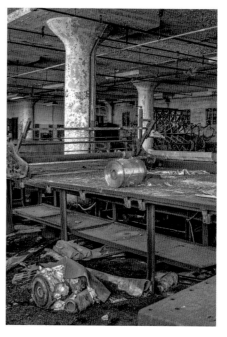

◄ **LIGHT STREAMING ON GRAFFITI RESEMBLES STAINED GLASS IN THIS WAREHOUSE SECTION:** In 1911, after the first full year of production, 362,000 pounds of yarn was manufactured at the viscose factory.

► **PRODUCTION WORKROOM:** United States rayon production and its success are credited to the farsightedness of Samuel Savage.

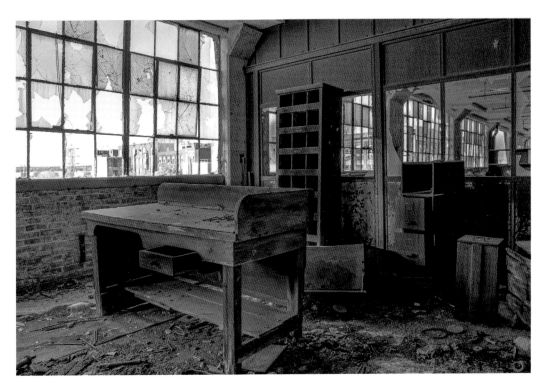

PRODUCTION WORKROOM: In 1909, Samuel Savage wrote to rayon producers in England, Courtaulds & Co., and suggested viscose patents be purchased for the United States market as well as the construction of an American viscose manufacturing plant.

TIME CLOCK: In 1924, rayon was the chosen name for artificial silk. Other names suggested were: glos, filatex, glistra, filacel, and klis (silk spelled backward).

14

RURAL MISERIES:
ABANDONMENT OF A LIFESTYLE

C ollapsing silos, disintegrating barns, derelict farmhouses, empty storefronts in small towns supporting rural areas—familiar scenes in rural United States regions, with Eastern Pennsylvania certainly not an exception. The decline in the number of family farms is a continuing trend. Rural areas continue to dominate the United States landscape, however, and cover a surprising ninety-seven percent of the landmass, even though only nineteen percent of the American population resides in rural areas. Given these statistics, many rural residents must question their stake within the American prosperity machine.

Agriculture formed America, with towns born from farming districts. Rail routes enabled towns to spring up, and the rail lines assisted farmers in transferring their agricultural products to the marketplace. Light manufacturing became an attribute to many of these small towns, but these industries have also suffered the adverse effects of fading rural America.

Historically, as modernity made an appearance, farms continued to grow, and the number of people supporting the workings of farms lessened. The people remaining in these rural pockets sill love their land and communities, but these communities suffer hardships because services and retail markets disappeared. A visit to the nearest hospital, doctor's office, grocery purveyor, or drugstore often requires a lengthy drive due to the rural town's lack of support for such needs.

For a long time, rural America remained stable when compared to the problems endemic of urban environments. During the first half of the twentieth century, America's Eastern Pennsylvania cities expanded into centers for heavy manufacturing with prosperity and growth often seen at exponential rates. By the 1960s, though, inexpensive land in the suburbs, and extensive highway and mortgage options provided former city residents with a quick escape to the solitude of the suburbs. Cities paid the price for the population flight to the suburbs, with many urban neighborhoods in a state of abandonment. Additionally, with heavy manufacturing feeling the pinch from foreign competition, job loss and a diminishing municipal

tax base ensued, thus forcing the urban socio-economic problems to escalate. In short order, drugs, crime, and poverty were common urban attributes.

Up until the mid-1990s, rural America avoided these urban socio-economic troubles and continued to flourish. It was not long, however, until rural America faced its own set of costs. A shift to a knowledge-based and service economy within the United States transformed many cities into lures for high-wage jobs. Once again, cities were attractive as home bases. For many workers that grew up in the suburbs, as well as immigrants, cities provided the diversity and concentration that augmented attractive prospects for work and recreation. Some city dwellers, nonetheless, were dismayed by this urban repopulation trend. Urban residents that never participated in the flight to the suburbs saw gentrification take hold on their home turf. Urban homes experienced escalating property assessments, along with rising tax bills, causing many low-wage earners to relocate to the outer city bounds.

At the same time, even though urban centers adapted to the changing economies of scale and digital technologies, rural pockets failed to adjust and struggled to find the means for economic survival. While federal and state anti-poverty programs were not limited to addressing the needs of the urban poor, many of these platforms failed to grasp the realism and struggle of the rural underprivileged. For most of United States history, there has been a wage gap between those employed in urban *versus* rural areas, but the 2008 recession created an enormous chasm. More employers left small communities, and many of the young left as well, with exodus trends similar to the Eastern Pennsylvania coal communities that suffered economic loss with the advent of oil and gas as the preferred energy source. Further, medical administrative consolidation shuttered many rural hospitals; retail and services took flight, and the abandonment of farms and homes became a common reality—a landscape of loss.

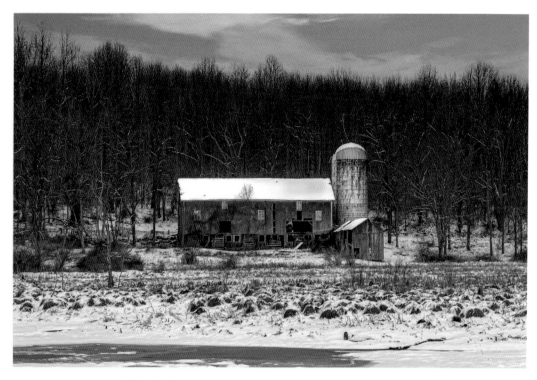

BARN AND SILO: In the 1930s, the United States government initiated economic policies to move people from farms and into manufacturing sectors, and especially the mining sector in Eastern Pennsylvania.

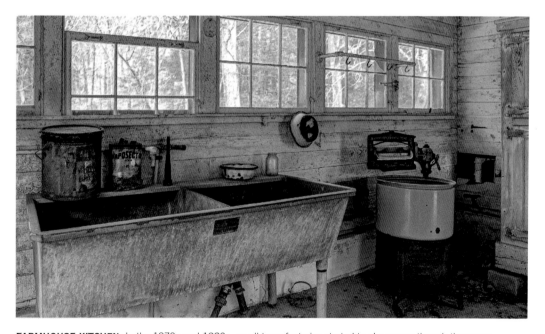

FARMHOUSE KITCHEN: In the 1970s and 1980s, small town factories started to close even though they were able keep rural areas economically afloat prior to this time.

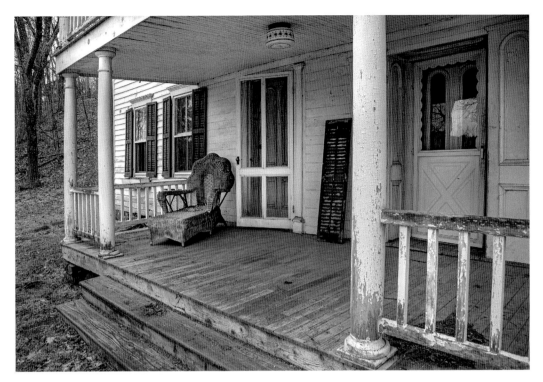

FARMHOUSE FRONT PORCH: Since the 1990s, thinly populated counties have replaced large cities as America's most precarious areas based on socioeconomic comfort and security criteria.

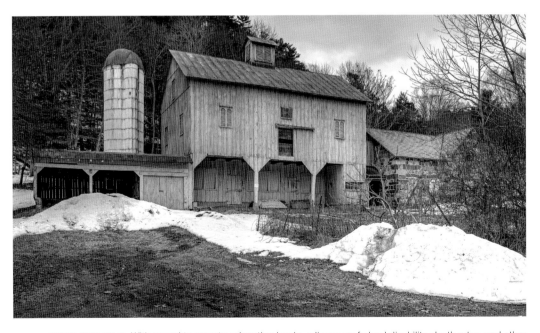

BARN AND SILO: With regard to poverty, education levels, reliance on federal disability, death rates, and other factors, rural areas now rank at the bottom among the four major United States population sectors—rural, big cities, suburbs, and medium/small metropolitan areas.

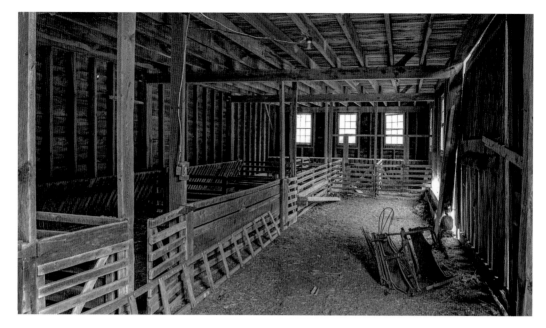

BARN INTERIOR: The rural population has continued to decline for seven years.

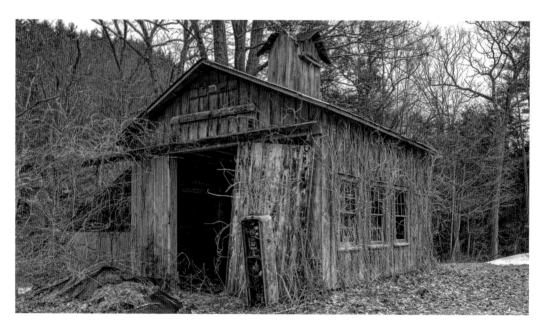

FARM GARAGE AND VINTAGE GAS PUMP: Just mere decades ago, new technology, primarily the internet, promised to aid citizens of rural areas, especially concerning telecommuting and providing companies with opportunities for investment outside of urban centers, but this realization never occurred.

Opposite page

CANOE INSIDE FARM GARAGE: By the late 1990s, the nation's shift to a knowledge-based economy altered cities into areas of desirable high-wage jobs.

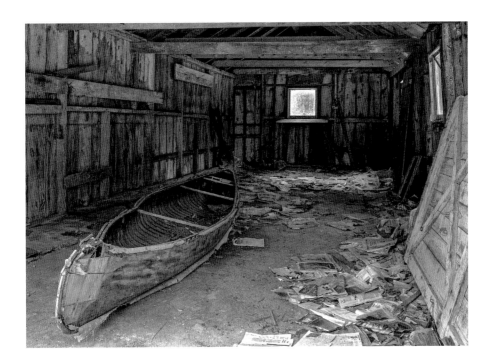

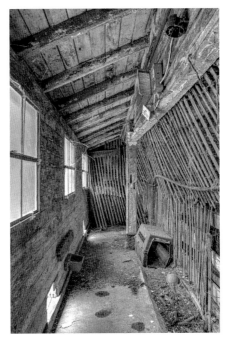

◀ **REMNANTS INSIDE A BARN:** A wide wage gap between workers in urban and rural areas existed for a while, but with the 2008–2009 recession, the gap widened. The average urban wage is one-third higher than in less populated areas that have 250,000 or fewer workers.

▶ **OUTER CORRIDOR OF BARN INTERIOR:** Since the collapse of the housing market in 2008, real estate appreciation in rural areas has trailed behind cities and eradicated the primary source of prosperity and savings for many.

15

LOVE IS DEAD:
POCONO MOUNTAINS HONEYMOON RESORT

In scenic Eastern Pennsylvania's Pocono Mountains, resorts catering to love were standard fixtures at one time, and the region deserved its moniker, "the Honeymoon Capital of the World." For more than two decades, the honeymoon capital watched its slogan's luster fade. Where tributes to love once dotted the Pocono landscape, abandoned honeymoon resorts are now the norm.

Pennsylvania's Pocono Mountains were always a lure for adventurers. The rugged Pocono wilderness appeals to many. In the years after the Civil War, people would travel by train from New York City, Philadelphia, Boston, and Washington, D.C., to soak in the beauty of Pocono dense forests, nature, lakes, and waterfalls. In the post-World War II period, the Poconos's solitude and beauty was the perfect setting for developers interested in the creation of honeymoon resort facilities. Soldiers returning from World War II, and later Vietnam, would find an ideal and calming post-wedding retreat within the beauty of the Pocono region.

In the 1960s, the romance industry exploded, and couples-only resorts featured red heart-shaped or 7-foot-high champagne glass Jacuzzi bathtubs for two. With fireplaces and round beds as bedroom staples, mirrors were substitutes for wallpaper and ceiling tiles. Some deluxe rooms or cottages held private pools. Additionally, most resorts included tennis courts, indoor and outdoor pools, nightclubs, and other comforts within a honeymoon package.

Even though a few honeymoon resorts remain in the Poconos, in the late 1990s and early 2000s, the economic success of the business of love dwindled. Many of the old resorts faced neglect due to a financial downturn in bookings. Maintenance costs exceeded revenue from diminished reservations, and efforts to modernize a resort faced a stranglehold of new state and county rules and regulations. Moreover, competition between resorts intensified when more modern retreats opened with new amenities, along with neighboring states jumping into the hospitality fray. Finally, due to economies of scale, the trend of the destination honeymoon with excursions outside of the United States took hold within the last few decades, thus further sealing the doomed fate of the Pocono honeymoon resorts.

I visited a massive abandoned honeymoon resort in the Pocono region, and the site displayed unfortunate evidence of rampant vandalism. The bell-shaped outdoor swimming pool was still evident, but the pool now held pool furniture, assorted trash, and even a few heart-shaped tubs barely visible in the pool's murky water. A few rooms contained the notorious red heart tubs, round beds, and fireplaces. Although there was extensive destruction of almost all guest room contents, it was unmistakable that mirrors once affixed to every flat surface except the floor, despite endless broken pieces of mirrors assuming the place of carpeting. In essence, the site was nothing more than a crumbling, wrecked, 1970s colored-relic with shag carpeting and brass trim.

This resort site originally held a tavern and inn when it opened in 1943. The tavern's business was brisk, but a major flood in 1955 destroyed the buildings on the property. The owner did not rebuild the tavern but instead constructed 100 rooms, villas, and cabins with a design for romance. The site became one of the most successful honeymoon resorts during its long tenure. The owner passed away in 2009, and a Pocono county government acquired the property. The county sold 500 acres of the property and the golf course, but much of the resort's footprint is still derelict. In addition to vandalism, arson has been a frequent guest of this site. The site presents an image of abandonment for decades instead of just one decade due to the widespread property damage. With destroyed guest rooms, graffiti on virtually any surface accepting paint, and scrappers stripping copper and steel, perhaps this sad business of romance is a blatant metaphor for many that spent a few nights or weeks here. Indeed, the crumbling honeymoon resorts of the Poconos might represent how a majority of marriages end in divorce. To me, this place is nothing more than a visual representation of the human turmoil of fallen dreams or lost love.

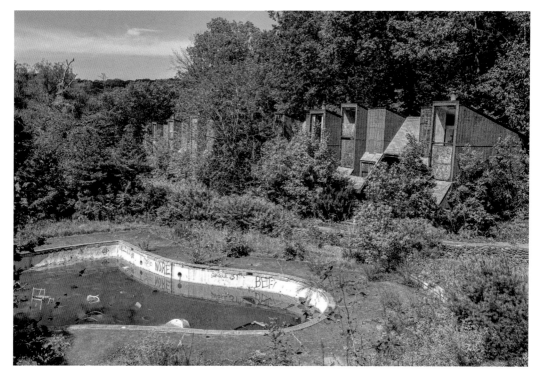

WEDDING BELL-SHAPED POOL AND GUEST ROOMS IN BACKGROUND: The first Pocono resorts opened in the early 1900s. In the 1940s, resorts catering to honeymooners appeared across the Pocono landscape.

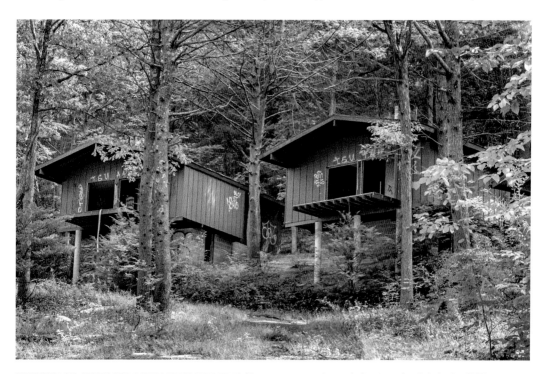

HONEYMOON COTTAGES ON WOODED HILLSIDE: Honeymoon resort popularity started to fade in the 1970s and now the Pocono landscape is littered with abandoned honeymoon resorts.

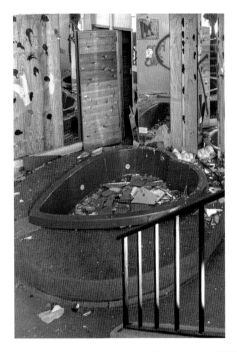
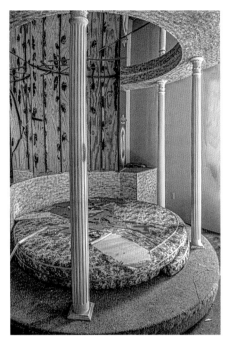

◄ **HEART-SHAPED TUB IN GUEST ROOM:** In 1963, Morris Wilkins, owner of the Cove Haven Resort, invented the heart-shaped tub. Other honeymoon resorts adapted this design into their rooms and cottages. Cove Haven is still open for business.

► **ROUND BED:** Morris Wilkins also invented the tall champagne-glass whirlpool tub found in several honeymoon resorts.

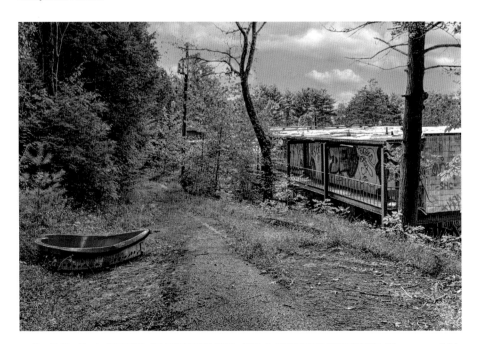

NATURE TRAIL, A SECTION OF GUEST ROOMS, AND A RUNAWAY HEART TUB: The owner of this room resort passed away at 102, and shortly after his passing, the resort closed.

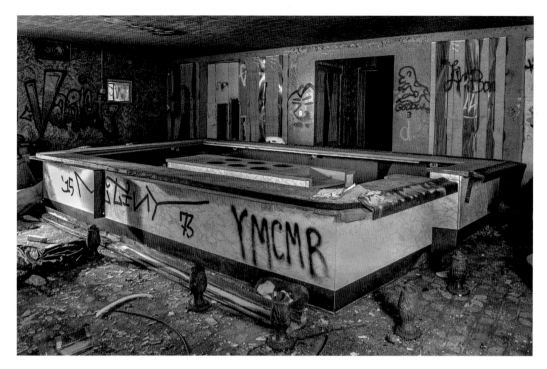

LOW RISE BAR WITH MISSING BAR STOOLS: In the early days of honeymoon resorts, one had to present a marriage certificate to reserve a room.

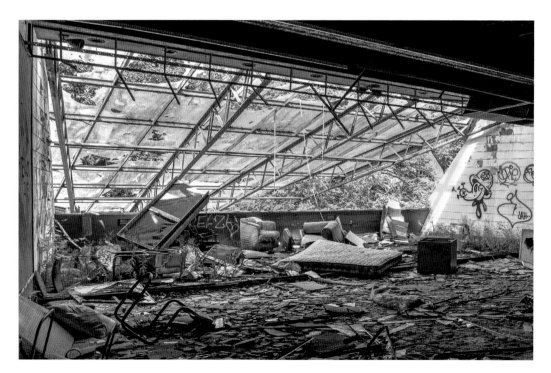

FORMER LOUNGE AND ENTERTAINMENT FACILITY: Graffiti and broken glass are common features. All of the guest room floors were covered with broken mirror pieces because mirrors covered almost all flat surfaces in the rooms, including the ceiling.

BIBLIOGRAPHY

Adelman, J., "'Graffiti Pier's Deal to Turn Beloved Philly Urban Ruin Into Next Park Along Delaware River Waterfront," *Philadelphia Inquirer*, June 3, 2019, www.inquirer.com/real-estate/graffiti-pier-public-park-conrail-delaware-river-waterfront-20190603.html.

Akbar, J., "Haunted Ruins of the Tortured: The Ghostly Remains of U.S. Prison Where Disabled Citizens and Inmates Were Experimented on by the Government," Daily Mail Online, Associated Newspapers, April 16, 2015, www.dailymail.co.uk/news/article-3038202/Haunted-ruins-tortured-ghostly-remains-U-S-prison-disabled-citizens-inmates-experimented-government.html.

Anderson, A., "Prisons and Jails," Encyclopedia of Greater Philadelphia, 2019, philadelphiaencyclopedia.org/archive/eastern-state-penitentiary/.

Arvedlund, E. E., "Keeping Mount Moriah Cemetery, and Its Memories, Alive." www.inquirer.com, *The Philadelphia Inquirer*, April 10, 2016, www.inquirer.com/philly/business/20160410_Keeping_Mount_Moriah_Cemetery__and_its_memories__alive.html.

Bates, D., "Facebook Will Become the World's Biggest Virtual Graveyard by the End of the Century, Say Experts," Daily Mail Online, Associated Newspapers, March 6, 2016, www.dailymail.co.uk/news/article-3479288/Facebook-world-s-biggest-virtual-graveyard-profiles-dead-people-living-users-end-century-say-experts.html.

Boone, A., and CityLab, "The Fate of the Rust Belt, in 24 Cities," CityLab, May 8, 2018, www.citylab.com/life/2017/09/the-overlooked-cities-of-the-rust-belt/538479/.

Bucks County Historical Society, Special Fonthill Anniversary Edition, Special Fonthill Anniversary Edition, Penny Lots, 2012.

Cahal, S., "American Viscose Company," Abandoned Online, Abandoned Online, April 17, 2019, abandonedonline.net/location/american-viscose-company/.

Cernasky, R., "Virtual Cemeteries: Choose Your Final Resting Place...Online," *Discover Magazine*, April 28, 2009, www.discovermagazine.com/technology/virtual-cemeteries-choose-your-final-resting-placeonline.

Cheney, J., "Hidden History: Inside the Abandoned J.W. Cooper School in Shenandoah, Pennsylvania," UncoveringPA, July 8, 2019, uncoveringpa.com/inside-abandoned-jw-cooper-school-shenandoah-pennsylvania; "Mount Moriah Cemetery: Philly's Overgrown Burial Grounds," UncoveringPA, July 3, 2019, uncoveringpa.com/exploring-moriah-cemetery-philadelphia; "Visiting Fonthill Castle: One of Pennsylvania's Most Awe-Inspiring Buildings," UncoveringPA, February 18, 2015, uncoveringpa.com/visiting-fonthill-castle.

DeRaymond, J., "Requiem for Bethlehem Steel?" CounterPunch.org, December 12, 2015, www.counterpunch.org/2005/10/29/requiem-for-bethlehem-steel/.

Donald, W., "Restructured Steel Firms Face New Problems," *Los Angeles Times*, February 9, 1992.

Dublin, T., *Life after the Mines Closed* (Cornell University, 2014), life-after-mines-closed.pdf.

FavSightsSounds, "J.W. Cooper Abandoned School – Shenandoah, PA – 5/27/17." *Favorite Sights & Sounds*, December 16, 2017, favoritesightsandsounds.com/2017/12/16/j-w-cooper-abandoned-school-shenandoah-pa-5-27-17/.

Flock, E., "In 'Scranton Lace,' Nostalgia for a Time and Place That No Longer Exist," PBS, Public Broadcasting Service, May 15, 2017, www.pbs.org/newshour/arts/poetry/scranton-lace-nostalgia-time-place-no-longer-exist.

Goran, D., "Once the Largest Producer of Nottingham Lace in US, Closed in the Middle of the Daily Work Shift," *The Vintage News*, July 30, 2016, www.thevintagenews.com/2016/07/30/abandoned-scranton-lace-company-largest-producer-nottingham-lace-us-closed-middle-daily-work-shift/.

Handley, S., *Nylon: the Story of a Fashion Revolution: a Celebration of Design from Art Silk to Nylon and Thinking Fibres* (Johns Hopkins University Press, 1999).

Hardy, M., "America's Grandest Movie Palaces Find Strange New Lives," Wired, Conde Nast, April 23, 2019, www.wired.com/story/americas-grand-movie-palaces-gallery/.

Harris, R. L., and Tarchak, L., "Small-Town America Is Dying. How Can We Save It?" *The New York Times*, December 22, 2018, www.nytimes.com/2018/12/22/opinion/rural-america-economy-revive.html.

Henninger, D., "Graffiti Pier Is Becoming a Public Park: 5 Things to Know," Billy Penn, June 4, 2019, billypenn.com/2019/06/04/graffiti-pier-is-becoming-a-public-park-5-things-to-know/.

Hider, A., "These Abandoned Honeymoon Resorts Are Where Love Goes to Die," *Roadtrippers*, March 1, 2019, roadtrippers.com/magazine/abandoned-honeymoon-resorts/.

"Historic Lansdowne Theater Corporation," Lansdowne Theater, www.lansdownetheater.org/history.

Hornblum, A. M., *Acres of Skin: Human Experiments at Holmesburg Prison* (Routledge, 2012).

Huang, B., "Pennsylvania Coal Region's Industry Burned out. What Remains Are Pockets of Poverty Where Sick People Get Sicker," Mcall.com, *The Morning Call*, April 1, 2019, www.mcall.com/news/watchdog/mc-nws-health-coal-country-project-20181216-htmlstory.html.

Kleiner, K., "Steel Companies Crying Foul," *Baltimore Business Journal*, July 10, 1992.

Lake, M., *et al.* "Pennhurst Asylum: The Shame of Pennsylvania," Weird NJ, February 7, 2013, weirdnj.com/stories/pennhurst-asylum/.

Leech, B., *et al.* "LIGHTS! MUSIC! ACTION! Historic Lansdowne Theater Poised For A Comeback," Hidden City Philadelphia, October 11, 2017, hiddencityphila.org/2017/10/lights-music-action-historic-lansdowne-theater-poised-for-a-comeback/.

Lockwood, J., "Scranton Planners Hear Update on Laceworks Village Project," Google News, February 28, 2019, www.thetimes-tribune.com/news/scranton-planners-hear-update-on-laceworks-village-project-1.2451067.

Mattei, M., "Irem Temple Building Has History of Celebration, Entertainment," *Times Leader*, January 25, 2017, www.timesleader.com/features/628519/irem-temple-building-has-history-of-celebration-entertainment.

Maurer, P. I., "Abandoned D.C.: Honeymoon in the Poconos," DCist, October 28, 2018, dcist.com/story/14/01/08/abandoned-dc-honeymoon-in-the-pocon/.

McCoy, M. K., "As America's Small Towns Are Disappearing, Photojournalist Documents 'Golden Age'," Wisconsin Public Radio, July 26, 2018, www.wpr.org/americas-small-towns-are-disappearing-photojournalist-documents-golden-age.

Millsap, A., "The Rust Belt Didn't Adapt And It Paid The Price," *Forbes*, January 9, 2017, www.forbes.com/sites/adammillsap/2017/01/09/the-rust-belt-didnt-adapt-and-it-paid-the-price/#7bfdd4eb7a3d.

Nadler, M. R., "Inside An Abandoned Honeymoon Destination In The Poconos," Gothamist, March 30, 2016, gothamist.com/arts-entertainment/inside-an-abandoned-honeymoon-destination-in-the-poconos.

"New Census Data Show Differences Between Urban and Rural Populations," United States

Census Bureau, Release Number CB16-210, December 8, 2016, www.census.gov/newsroom/press-releases/2016/cb16-210.html.

Nobel, J., "The Looming Death Of The Small Town American Cemetery," Digital Dying, August 15, 2018, www.funeralwise.com/digital-dying/the-looming-death-of-the-small-town-american-cemetery/.

Nolan, K., "Steel Days: On a Modest Resurgence in Bethlehem," *Pacific Standard*, November 23, 2015, psmag.com/economics/steel-days-a-modest-resurgence-in-bethlehem.

Orenstein, R. H., "CINDERELLA LIVES IN LANSFORD," Themorningcall.com, December 16, 2018, www.mcall.com/news/mc-xpm-1988-03-28-2610755-story.html.

Papa, D., "Stones and Stories at Mount Moriah Cemetery," Hidden City Philadelphia, August 23, 2019, hiddencityphila.org/2013/07/stones-and-stories-at-mount-moriah-cemetery/.

Paul, J., and Collier, B., "Concrete Evidence," *Washington Post*, April 7, 1999, pp. C09–C09.

Pollock, J., *The Rationale for Imprisonment* (Texas State University, 2010).

Radzievich, N., "Bones Unearthed during Road Project May Be Spanish Flu Victims," Mcall.com, August 30, 2015, www.mcall.com/news/local/mc-schuylkill-county-spanish-flu-mass-grave-20150829-story.html.

Simeone, C., and Okiro, T., *Reimagining Pennsylvania's Coal Communities* (University of Pennsylvania, May 23, 2018), kleinmanenergy.upenn.edu/sites/default/files/proceedingsreports/Reimagining%20Pennsylvanias%20Coal%20Communities_0.pdf.

Solomon, A., "The Granite Memorial Industry Needs to Think Outside the Cemetery," U.S. News & World Report, May 17, 2019, www.usnews.com/news/best-states/articles/2018-05-17/a-dying-industry-memorial-makers-want-to-avoid-that.

Spikol, L., "The Illicit Draw of Graffiti Pier," PhyllyMag, November 8, 2015, www.phillymag.com/news/2015/11/08/graffiti-pier-philadelphia/

Staff, 2017 Pennsylvania at Risk, Preservation Pennsylvania, 2017, 2017-PA-At-Risk_Preservation-PA_Lores.pdf; "American Viscose Company Historical Marker," ExplorePAHistory.com, 2019, explorepahistory.com/hmarker.php?markerId=1-A-315; "Fonthill Castle," Mercer Museum & Fonthill Castle, 2019, www.mercermuseum.org/about/fonthill-castle/; "Forging America: The History of Bethlehem Steel," *The Morning Call Supplement*, 2003; The History of the Shriners, www.rizpahshriners.org/shrinershistory.htm.

"Suffer the Little Children," created by Bill Baldini, season 1968, episode 1–5, NBC, 1 July 1968, documentaryheaven.com/suffer-little-children/.

Talvi, S., "The Prison as Laboratory," Alternet.org, July 23, 2012, www.alternet.org/2002/01/the_prison_as_laboratory/.

Terruso, J., "Philly Police Shut down Graffiti Pier, Citing Safety Concerns," *The Philadelphia Inquirer*, May 1, 2018, www.inquirer.com/philly/news/philly-police-shut-down-graffiti-pier-after-a-string-of-car-thefts-20180501.html.

Tseng, S., and Tseng, "Get Down to Graffiti Underground," *34th Street*, August 28, 2017, www.34st.com/article/2017/08/graffiti-underground.

Wescoe, S., "Memories Surface as Martin Tower Demolition Looms," LVB, February 8, 2019, www.lvb.com/memories-surface-as-martin-tower-demolition-looms-2/.

Wykstra, S., "The Case Against Solitary Confinement," Vox, April 17, 2019, www.vox.com/future-perfect/2019/4/17/18305109/solitary-confinement-prison-criminal-justice-reform.

Yakutchik, M., "Closing Pennhurst Sets Right Procedure," *Reading Eagle*, January 24, 1988, pp. A1–A3.

ABOUT THE AUTHOR

CINDY VASKO was born in Allentown, Pennsylvania, and resides in Arlington, Virginia, near Washington, D.C. For fifteen years, Cindy was the publications manager for a large construction law firm in Northern Virginia, and concurrently, interviewed musicians, wrote articles, and photographed concerts for a music magazine for four years. While Cindy enjoys partaking in all photography genres and is a multifaceted photographer, she has a passion for abandoned site photography. Cindy is an award-winning photographer, and her works were featured in many gallery exhibitions, including galleries in New York City, Washington D.C., Philadelphia, Pennsylvania, and Paris, France.

Cindy's Abandoned Union series books include: *Abandoned New York*; *Abandoned Maryland: Lost Legacies*; *Abandoned Western Pennsylvania: Separation from a Proud Heritage*; *Abandoned Catskills: Deserted Playgrounds*; *Abandoned Southern New Jersey: A Bounty of Oddities*; *Abandoned Northern New Jersey: Homage to Lost Dreams*; *Abandoned West Virginia: Crumbling Vignettes*; *Abandoned Washington, D.C.: Evanescent Chronicles*; *Abandoned Eastern Ohio: Traces of Fading History*; and coming soon, *Abandoned Northern Virginia: Desolate Beauty*; *Abandoned Southern Virginia: Reckless Surrender*; and *Abandoned Salton Sea: Dystopian Panoramas*.